Copyright © 2003 Susan Scheewe Publications Inc.
13435 N.E. Whitaker Way - Portland, Or. 97230
PH(503)254-9100 Fax (503)252-9508
PRINTED IN THE USA
e-mail: scheewepub@aol.com
web site: http://www.painting-books.com

Gran's Workbook

This book is meant to be a textbook/workbook to help you paint beautiful flowers and fruits. I feel I can show you better than I can tell you. I will try to answer the most often asked questions and try to explain in more detail.

May you always find joy in painting beautiful gardens, gorgeous armloads of flowers and luscious fruit.

Gran's Girls, *Paige who is almost 10 and Caroline who is 8 are growing into beautiful young ladies. We are delighted to add Catherine age 6 to our family.*

We have added to our family!
We are delighted to welcome our new grandson. Our son Scott and his wife Linda are the proud parents of Nicholas Spencer Stallcup. Nicholas was born May 1, 2003, 7lbs. 14 oz. 19 3/4".

Ros Stallcup
1436 Lakeview Drive
Virginia Beach, Va. 23455
757-464-4974 Fax 757-464-4185
E-mail: Stalcop@aol.com
Web site: www.gransgarden.com

D1294950

Supplies

All painting supplies can be purchased at your local art and craft stores. Some may be found in hardware stores or paint and wallpaper stores. Whenever possible I have listed source information.

Paints

*I have used **DecoArt Americana Acrylic** paints. Colors are listed for each project and always refer to the color pictures. Similar colors will work. It doesn't have to be exactly the same shade. Make your own color charts. Put your color samples alphabetically in an inexpensive address book. Take your book with you to classes where paints are supplied and add those colors too.*

Brushes

***Suzie's Foliage Brush** is a natural bristle brush cut on an angle. All other brushes are soft synthetic hair.*

> Flats Shaders - #4, 6, 12 and 16 Rounds - # 2 and 5
> Liner - #0 Angular Shaders - 3/8", 1/2" and 3/4"
> Filberts (Cat's Tongue) - # 2, 4, 8 and 12 Oval Wash Brush - 1/2"
> Lettering Brush - 1/8" # 580 Winsor Newton
> Fan Brush 2/0 (#916 Stan Brown's Arts and Craft) or 10/0 Loew Cornell
> Suzie's Foliage Brush - 1/4", 1/2" and 3/4" (Scheewe Foliage Angular, S8037 Martin/F. Weber)

General Supplies

- Water Container
- Paper Towels
- Tracing Paper
- Plastic T-square
- J.W. White Lightening
- Scheewe Gesso
- Write-on Transparency Film (for practice and work sheets)
- Masking Tape (3M)
- Sharpie Ultrafine Pen - Black
- Sandpaper
- J.W. Wood Filler
- J.W. Right Step Waterbase Varnish
- Benjamin Moore Latex ChalkBoard Paint
- 9 x 12 Stay Wet Pallet with Deli-Wrap
- Stylus or Ballpoint Pen
- Graphite Paper - White and Gray
- J.W. First Step Wood Sealer

Helpful Hints

Think of these as practice projects. You are learning as you paint. Practice each flower or fruit on Write On Transparency Film (Office Supply). Actually paint your own worksheets by laying the clear film on top. Paint step-by-step guides for yourself. Save these sheets in a notebook and use them as design tools to help you create your own design.

Practice painting on a surface such as a piece of wood, glass jar, old crock, cookie tin, coffee can, old book, clay pot, or slate. Paint for the fun of it. Now combine these techniques and paint them on a beautiful tray or box.

Be patient with yourself. Practice makes the difference. If you are not happy with what you have painted then just re-paint it! Rubbing alcohol removes areas of dry acrylic from sealed wood, or simply allow the paint to dry and paint over. Do it again, and again, until you are satisfied.

Trace and transfer painting guides as you need to use them. As you practice you will find very quickly that you can paint many of these project s freehand without a pattern. Just transfer the large fruits, birds, cottages, watering cans and areas that you feel you need structure. This will allow you to adapt these designs to fit any piece of furniture, wall, or surface. You can paint the whole world.

Be generous with your paint. Pick up your colors often so that there is paint in the tip of the bristle. I have found that I can paint with a very light touch if there is enough paint in my brush. Texture in your paint is a good thing. A little texture will keep your colors bright and creates the shape of a petal. More Paint. More Paint.

Stay out of the water. If you want transparent color just pick up Glazing Medium.

Pull your brush through various colors on your palette without mixing them. The colors will form a "Mingled Mess". Mingled paint will create streaks that are more realistic in leaves and flowers.

Practice, Practice, and then Practice some more.

Heplful Hints continued

Good paint brushes are a must.

It is vital that you clean your brush often while you are painting. Frequent cleaning will keep paint from drying up in the ferrule of your brushes and ruining that great shape that is helping you paint beautiful flowers.

If you are consistently unhappy with your results buy a new brush.

Designs can be painted on almost any surface as long as you used the right materials. Get busy and practice on everything in sight. Remember you simply can not ruin a jar.

Paint Chalkboards
*I purchased **Benjamin Moore Latex Chalkboard Paint** in a paint and wallpaper store. Paint two coats on surface and you are ready to go. Always read the directions on the can. Paint the inside of one of your kitchen cabinets doors and it instantly becomes a message board. Varnish only painted areas and do not varnish over the chalkboard surface.*

Basic Wood Preparation
*Fill any holes with **JW Wood Filler** and let them dry completely. Sand level. I use **JW White Lightning** as a base coat on many pieces as it is also a great sealer. Be sure to stir **White Lightning** as pigment settles to the bottom. Paint with one generous coat only.*
*Leave the whitewashed effect of **White Lightning** or add a coat of acrylic color. Let the base coat dry completely and then sand lightly with fine sandpaper or use a brown paper bag. The final finish should feel smooth but not slick to the touch. If you have wood with lots of knots then first seal the wood with **JW First Step Wood Sealer** to prevent bleeding. Always read and follow the directions on the label.*

Pre painted or finished wood should be sanded lightly and it is ready to paint your designs. Wonderful things can be painted on old furniture without re-finishing or basecoating. Sand the existing surface, wipe off dust with a damp paper towel and proceed to create treasures. Sand again on top of painted piece to soften the effect and give a more antique look.

*Varnish completed pieces with **JW Waterbase Varnish**. Use **Finishing Wax** on furniture pieces.*

Crackle Medium
*DecoArt makes several types of "Crackle Medium". For background effects I have used **Weathered Wood**. To create cracks on top of a painted surface use **Perfect Crackle**.*
Read the manufacturers instructions and have fun creating great effects.

Tin or Galvanized Metal
I have had fun painting on unpainted tin and galvanized metal. Just sand lightly and paint your design. Varnish finished piece with Water Based Varnish.

To base with a color, the surface must be clean and free of rust. Sand lightly to rough the surface and then spray with a metal primer. Allow primer to dry and paint with two coats of acrylic (spray or brush on) of the desired base color.

*Pre-painted metal surfaces, such as mailboxes, should be sanded lightly then painted. Varnish your completed pieces with **JW Exterior Waterbase Varnish**. Re-varnish as necessary to protect them.*

Crocks
Make sure the surface is clean and dry. Paint with DecoArt Multi-Purpose Sealer (DS17) or spray with Krylon Matte Spray (1311). Paint with Americana Acrylic.

Heplful Hints continued on page 64

Background Foliage

Practice this foliage shape for a bouquet on a piece of transparency film.

Place your 3/4" foliage brush in your water container for a few minutes while you get your paint out.

Remove Foliage brush from water and dry. The natural bristle hairs absorb moisture and become flexible. Push on the heel of the brush to force the hairs to form a half circle. Push down on the table or your palette until the hairs stay open.

*Tap the front half of the brush into the edge of **Avocado** and tap up and down a few times in the edge of the color to open the hairs up. Start in the center of the foliage area using lots of paint and create a solid irregular shape. Now touch the hairs of your brush into **Glazing Medium** and continue to tap letting your shape grow and become lacey and open. The **Glazing Medium** will make the color more transparent but will keep the same consistency. Tap in **Evergreen** and deepen the color in the center area. Tap into the edge of **Blue Mist** and highlight areas of the green with irregular shapes like the tops of bushes or clouds. Pick up some **Glazing Medium** as you paint over the edges. Tap into **Olive Green** and create some light areas.*

*Add stem with your liner brush using **Glazing Medium** and each color pulling from inside the clump and crossing where you plan to place a bow. Add some little stems with **Olive Green** in the darker areas and in the lighter areas with **Avocado**.*

Let it dry. Save this practice page in your notebook to use as a design tool for placement and color on your wood piece. Overlay with any of your flower sheets to test for color and composition.

Pattern with graphite or sketch with a white chalk pencil on top of the foliage. Try painting some flowers using your pattern only as a visual guide for positioning. Paint bow, then large flowers, add leaves, filler flowers, stem & squiggles. Put flowers together as they please you. Remember this is just like putting flowers in a vase or tying a bunch up with a ribbon.

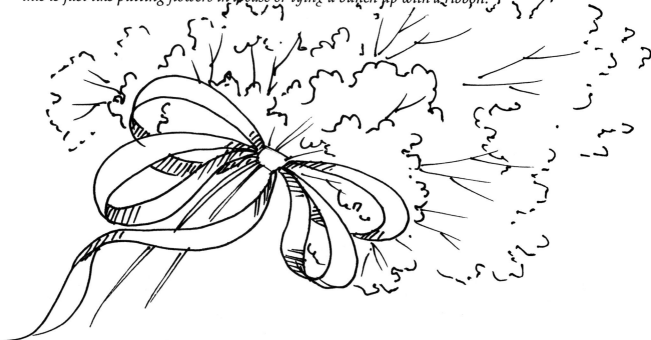

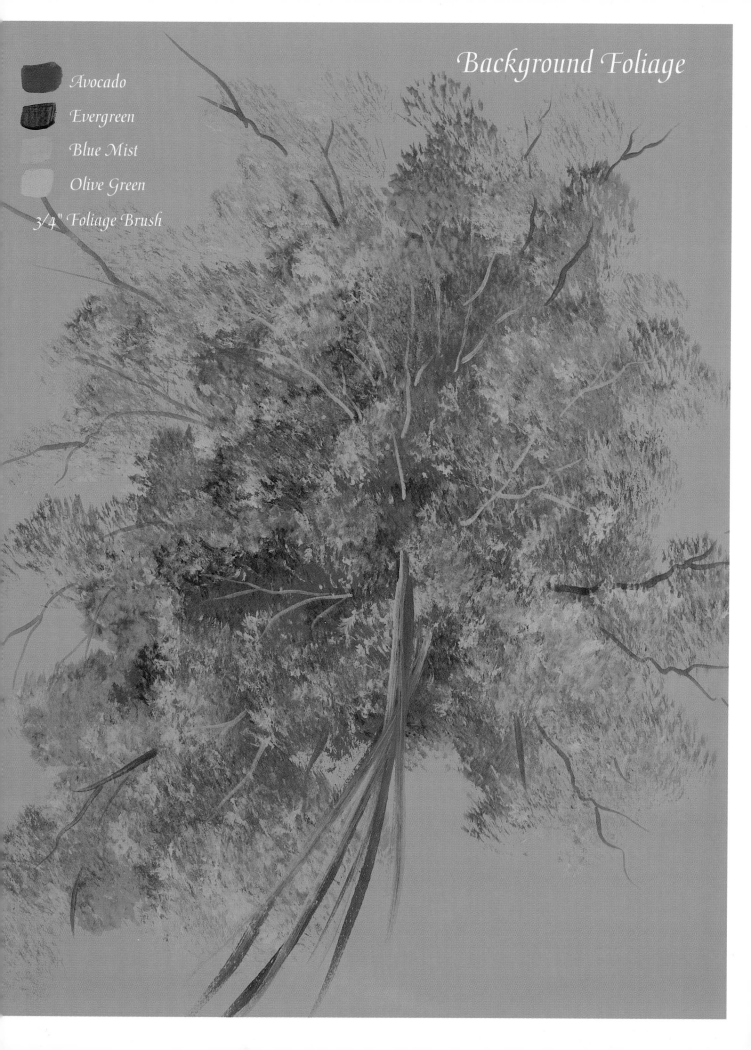

Avocado

Evergreen

Blue Mist

Olive Green

3/4" Foliage Brush

Background Foliage

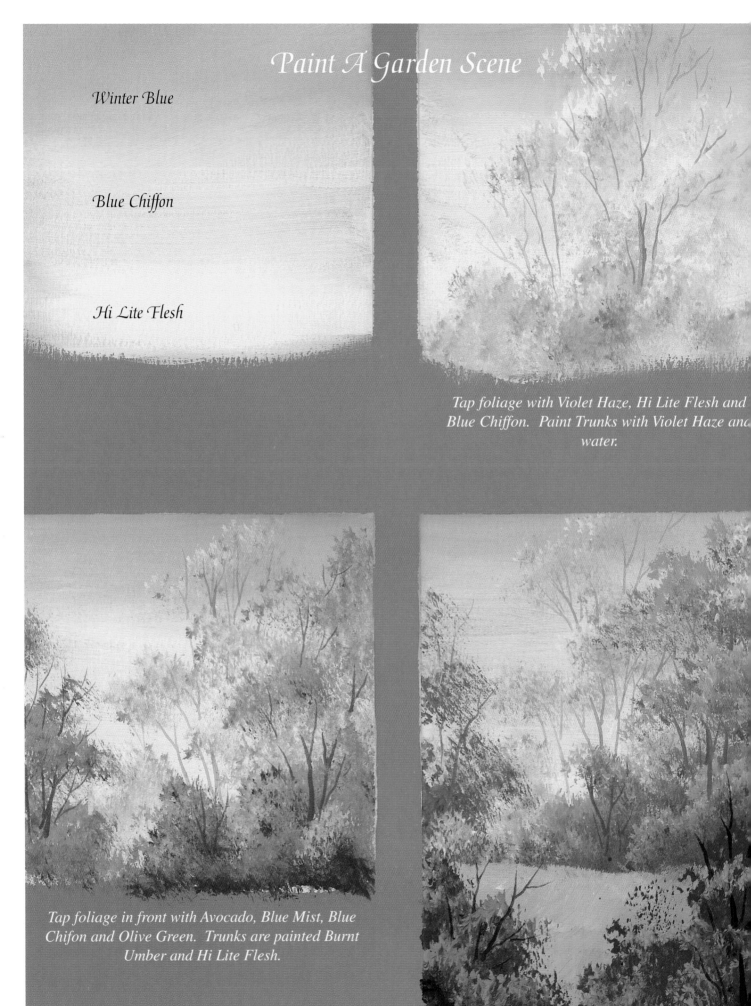

Paint A Garden Scene

Winter Blue

Blue Chiffon

Hi Lite Flesh

Tap foliage with Violet Haze, Hi Lite Flesh and Blue Chiffon. Paint Trunks with Violet Haze and water.

Tap foliage in front with Avocado, Blue Mist, Blue Chifon and Olive Green. Trunks are painted Burnt Umber and Hi Lite Flesh.

Garden Scene

Paint the sky with a large background brush, a Flat, Oval or Angle using lots of paint so that the paint dries slowly to give you time to blend the colors. As you get the area covered stop and let the paint dry, as it is easier to come back and make corrections.

Start painting the sky with **Hi Lite Flesh** at the horizon line. Use lots of paint and brush back and forth with short slip-slap strokes. Pick up **Blue Chiffon** and blend in to the top of wet **Hi Lite Flesh** continue working toward the upper sky. If you have trouble blending pick up more of the lighter value to help blend the two colors. Pick up **Winter Blue** in the upper 1/3 of the sky and blend into the wet **Blue Chiffon**.

Tap distant foliage with **Glazing Medium, Hi Lite Flesh, Violet Haze** and a bit of **Blue Chiffon** using 3/4" foliage brush. Start at the horizon line to form bushes. Pick up more **Glazing Medium** as you work up to create trees. Highlight some foliage with **Hi Light Flesh**. Leave some open areas to keep a loose airy feel. Paint trunk lines with water and **Violet Haze** using your liner brush.

Middle ground foliage is painted in the same manner with **Avocado, Blue Mist**, highlighted with **Olive Green** and **Blue Chiffon**. Paint trunks with **Burnt Umber** and a little **Hi Lite Flesh**.

Paint ground area with small fan brush and little pull down strokes using **Hi Lite Flesh** and a little **Olive Green**. **Blue Chiffon** and a little **Olive Green**. **Blue Mist** and **Olive Green**. Blend one area into another as you apply colors. Use lots of paint so the colors stay wet and allow you time to blend a little. Add more paint as needed.

Foreground foliage starts with **Avocado**, then add a little **Evergreen** at the bottom. Highlight the tops of bushes with **Olive Green** and **Blue Mist**.

You are now ready to add houses, gates, benches, trellis, gazebos and as many flowers as you want to complete your garden scene.

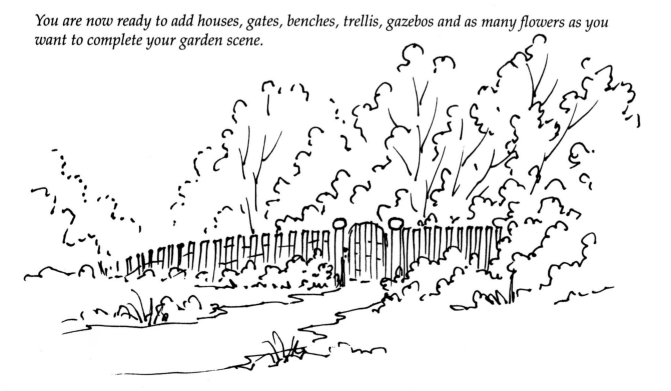

Bows

Bows can be painted any color to complement your design. Practice with the color of your choice on transparency film and save in your notebook to help design your piece. Put a small puddle of Glazing Medium on your palette and mix a small amount of color to the medium by pulling your 1/2" angle shader in the color.

Hold the brush with edge of the brush horizontal or parallel to the knot. Fix your hand and move your whole arm as you pull strokes to form ribbon. Let your brush do the work. Paint the knot first. Keeping the brush in the same position pull toward the heel of the brush away from the point. Start with very light pressure; apply some pressure as you pull "C" stroke to form the first half of the loop. Start your "S" stroke in same spot holding the brush in the same position using light pressure. Apply pressure and lift to form a gentle "S" stroke that connects with the "C" stroke.

Paint one loop on the right and one loop on the left. Paint a second loop on the right partially on top of the first. Make it larger or smaller, higher or lower to make it uneven. Paint second loop on the left in the same manner. Paint streamers with two gentle "S" strokes starting from the same point. Practice on top of the worksheet and then free hand your own ribbons so that you can form the loops in any size and any direction. Keep a damp paper towel in your hand so that you can remove any loop that does not please you while the paint is still wet.

Note: When you paint loops on your awkward side, turn you work so that it is easier to stroke but keep your brush parallel to the knot.

Paint small bows with the #2 round using the same technique. Start with very light pressure and apply pressure to make the stroke wider to form the loops of the bow.

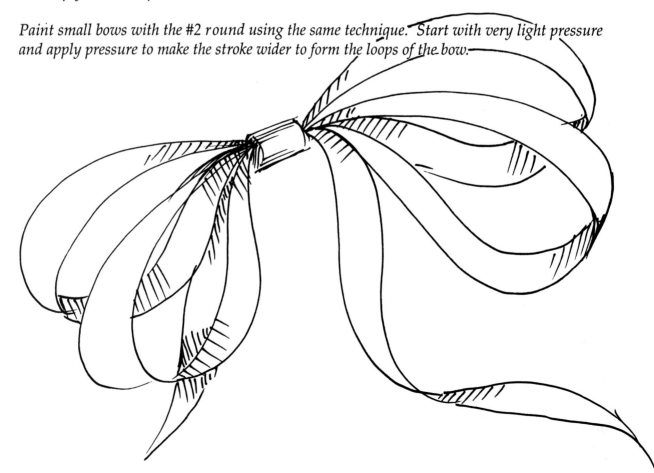

Bows

Blue Mist

Antique Teal

Titanium White

"C"

"S"

"S"

"C"

1/2" Angle Shader

#2 Round

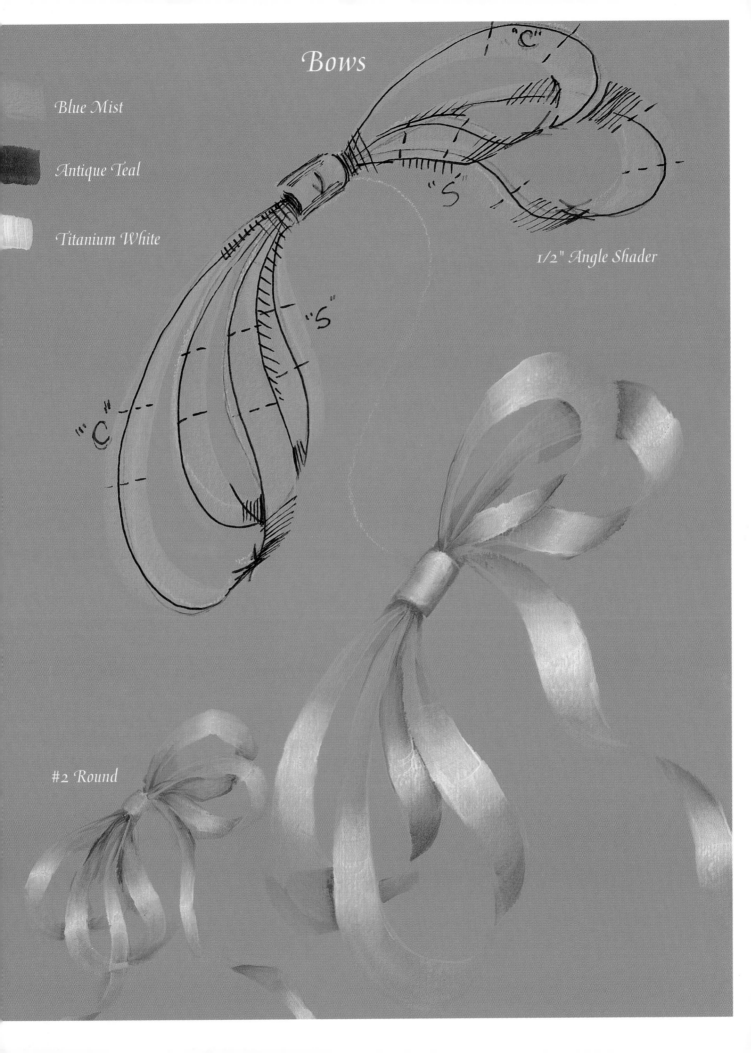

Birch Trees

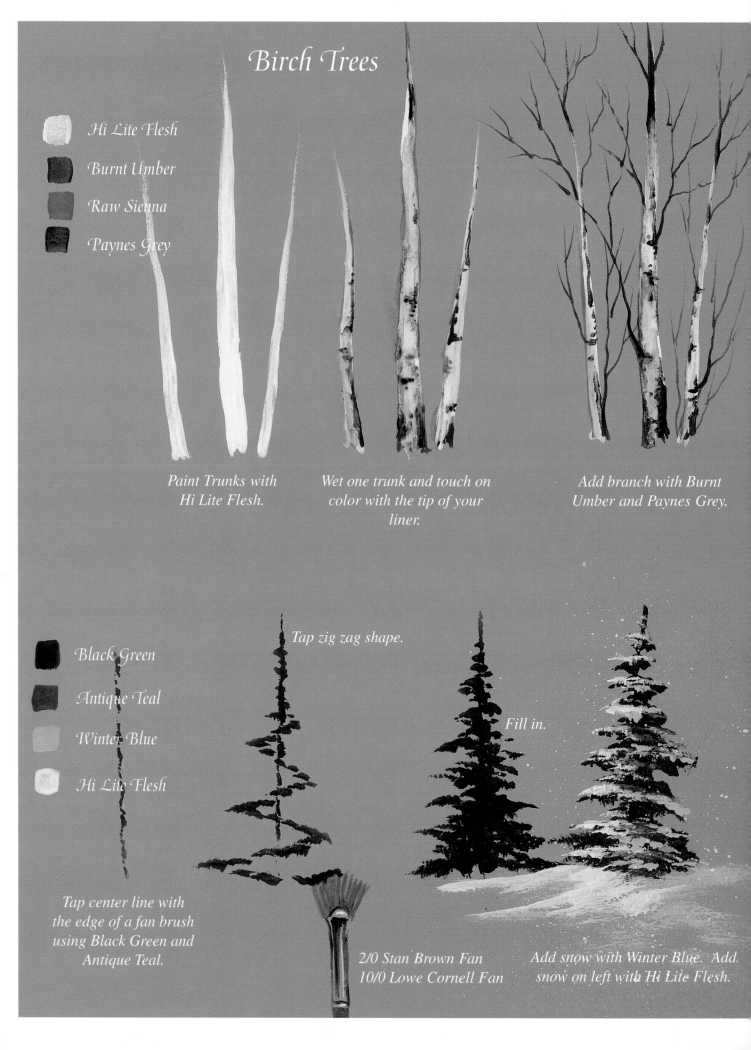

Hi Lite Flesh

Burnt Umber

Raw Sienna

Paynes Grey

Paint Trunks with Hi Lite Flesh.

Wet one trunk and touch on color with the tip of your liner.

Add branch with Burnt Umber and Paynes Grey.

Black Green

Antique Teal

Winter Blue

Hi Lite Flesh

Tap zig zag shape.

Fill in.

Tap center line with the edge of a fan brush using Black Green and Antique Teal.

2/0 Stan Brown Fan
10/0 Lowe Cornell Fan

Add snow with Winter Blue. Add snow on left with Hi Lite Flesh.

Birch Trees

Paint tree trunks with your liner (lots of paint) using **Hi Lite Flesh**. Note the position of the trunk. One is larger than the rest. Keep your spacing uneven.

Wet one trunk at a time with water using #2 round brush. Touch the tip of your liner brush into **Raw Sienna** and pull along the left side of the trunk. Wipe the brush and pick up tiny bit of **Paynes Grey** and touch trunk at bottom and here and there up the trunk. Add a few touches of **Burnt Umber**. Paint a few lines and dots to simulate bark. Paint branches with **Burnt Umber** and **Paynes Grey** with your liner brush and a little water. Start at trunk where there is a dark spot and pull toward tip adding a few twigs.

Fir Trees

Paint these fir trees with your small synthetic fan brush (2/0 Stan Brown or 10/0 Loew Cornell).

Load brush by pulling the brush flat through **Black Green** and **Antique Teal**.

Tap with the lower half of the vertical edge of the brush to create centerline of the tree. Turn brush horizontal and tip to use only the corner. Drop down 1/2" from the top of the line and make a small tap across the line, drop again and make another tap. Zig zag back and forth across the line to create the shape of the tree. Fill in the zig zag shape with uneven branches.

Tap snow using **Winter Blue** across the longer branches. Tap **Hi Light Flesh** on the left side of the **Winter Blue** snow to create a light source.

Using the back of your fan brush scuff with **Winter Blue** to create snow on the ground under the tree. Scuff **Hi Lite Flesh** on the left side of the **Winter Blue** snow. Spatter with **Hi Light Flesh** mixed with water using any stiff brush.

Chickadee

Trace and transfer birds carefully. Paint using #2 round and little short strokes to give the illusion of feathers.

*Wing - **Slate Grey.***

*Tummy and Cheek - **White.***

*Top of Head, Beak, Legs, Eye, Throat & Tail - mix of **Paynes Grey** & **Burnt Umber.***

Let Dry.

*Shade under the wing and at back end of tummy with glazing medium in the heel of 1/2" angle shader and **Paynes Grey** and **Burnt Umber** mix in the point (blend brush on palette). Glaze a little shadow at back of head. Load your brush with glazing medium in heel and **Raw Sienna** in the point and paint along outside edge of tummy. Slide streaks of **Glazing Medium** and **Paynes Grey** and **Burnt Umber** mix with the edge of angle shader on wing to create suggestion of feathers.*

*Highlight Eye with **White.** Reflected light in eye with **Raw Sienna.***

*Highlight Beak, Legs & Tail with **Slate Grey.***

Cardinal

Carefully trace pattern of cardinal and transfer using gray graphite.

*Paint the eye patch with **Paynes Grey** & **Burnt Umber** and paint the beak with **Raw Sienna,** using a small round or liner brush. Paint the rest of the cardinal with **Brandy Wine** leaving a small space to separate the wing and tail.*

*Shade the beak with **Raw Sienna** and **Burnt Umber** using a liner brush. Highlight the upper part of the beak with **Raw Sienna** and **White.***

*Create the eye by a tiny curve line in the lower left side with **Raw Sienna** and a tiny **White** highlight opposite.*

*Paint **Berry Red** over the body of the bird, leaving a small amount of **Brandy Wine** to separate the parts using short strokes with a #2 round. Let dry. Highlight with **Cadmium Orange** and **Cadmium Orange** plus a little **White** on the breast, top of head, tail and to accent feathers on the wing. Deepen under the tail and under the back of the wing with a little **Napa Red.** Use lots of paint so that the colors will dry bright. Add additional coats of paint as necessary.*

Chickadees

White

Slate
Grey

Raw
Sienna

Paynes
Grey

Burnt Umber

Brandy Wine

Berry Red

Cadmium Orange

Napa
Red

Cardinals

Base chest and cheek with White.
Base wing with Slate Grey.
Base head, tail and throat with Black.

Base body with Brandy
Wine. Eye-patch paint
with Paynes Grey and
Burnt Umber. Beak paint
Raw Sienna.

Slide streaks on wing with Paynes
Grey and Burnt Umber.

Shade body with
Paynes Grey and
Burnt Umber.

Detail eye with
Raw Sienna.
Add White
shine.

Pull strokes of Berry Red.
Add Cadmium Orange to
chest and head.

Glaze Raw
Sienna on
chest and
head. Add
Slate Grey to
beak and tail.

Detail eye with Raw Sienna, add
White highlight. Highlight beak
with Raw Sienna and White.
Shade lower section with Burnt Umber.

Flower Pots

Brandy Wine

Gingerbread

Burnt Umber

Paynes Grey

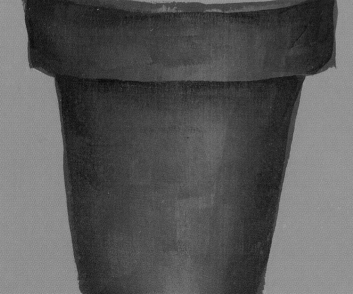

Base with Brandy Wine.

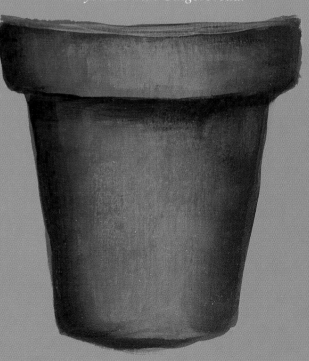

Highlight with double loaded brush
with Gingerbread and Brandy Wine.

Glaze shadows with Burnt Umber.

Strengthen shadows with Paynes Grey.
Drybrush with Gingerbread.

Flower Pots

Draw a centerline with your t-square; draw a line across the bottom and top of your pot. Measure across the bottom an equal distance from the center to each side. Measure across the top an equal distance from the center on both sides. Draw a line to connect the sides. Drop below the line at the bottom of the pot and draw a slightly curved line to round the bottom of the pot. Measure the same distance down from the top line and draw the same curve. Pots can be tall and skinny or short and squat. They can have a rim or be plain at the top.

Base flowerpots with **Brandy Wine**. Double load your 3/4" angle shader with **Gingerbread** in the heel and **Brandy Wine** in the point. Pick up lots of paint in your brush and pick up often as the extra paint will stay wet longer and give you time to blend. Start at the outside edge and pull short overlapping strokes working toward the middle. Pick up more paint and flip the brush over and work toward the middle from the other side blending in the center area. Paint over rim if you have one. Let dry.

Load your brush by touching the heel in **Glazing Medium** and pulling the point across the edge of **Burnt Umber**. Shade down both sides and slide the chisel edge across the bottom of the pot. Let dry. Glaze under the top edge and the rim with **Burnt Umber** and a little **Paynes Grey**. Glaze a little **Paynes Grey** down the left side. Paint extra **Gingerbread** on the center of the top edge. Dry brush some **Gingerbread** in the center of the rim and the pot. Brush lightly and let some paint catch the texture created earlier when we highlighted the pots.

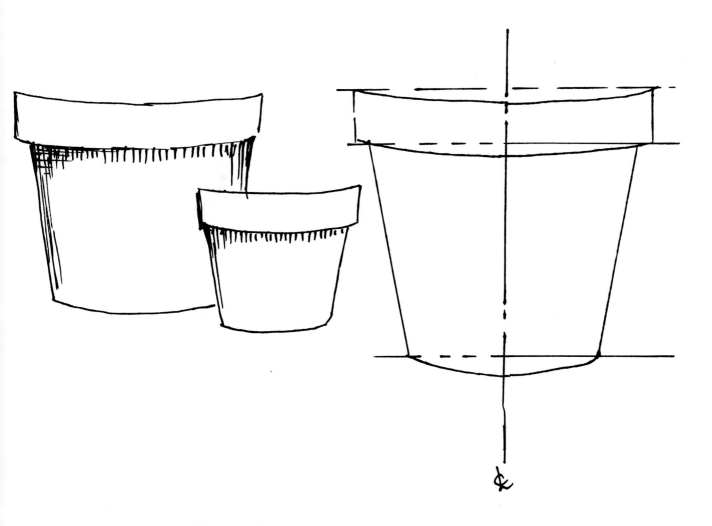

Baskets

Draw centerline for basket with t-square using chalk pencil. Measure across the bottom equal distance on both sides from the centerline. Measure across the top the same way. Baskets can have straight sides, slanted sides or curved sides. Draw them the same on both sides. Draw a line to connect top and bottom so that they are the same on both sides. The handle is in the middle. Make your basket fit your piece. It can be tall and skinny or short and wide. Base this shape with **Burnt Umber**. Let dry.

Draw a parallel line to the edge of the basket approximately 1/2" from the edge. Draw vertical lines across the basket about 1" apart following the shape of the basket to form ribs. Paint these ribs with **Raw Sienna** using the edge of your angle shader. I use 1/2" angle shader unless I am painting a tiny basket like the illustration.

Paint horizontal weave across one rib at a time using the chisel edge of your angle shader. Pick up **Raw Sienna** and **Camel** by pulling the brush through each color. Pick up fresh paint often. Start at the edge of the basket go across rib #1 and stop just before rib #2. Paint a row down rib #1 leaving only the width of your stroke in between each stroke. Start second row just to the left of rib#1 cross over rib #2 and stop just before rib#3. Each stroke fits in the space in between the strokes in the previous row.

Paint the outside of the handle with **Raw Sienna** and **Camel**. Paint the edge of the handle on the left side with **Camel** using #2 round. Paint a little **Raw Sienna** on the underside of the handle.

Paint strokes of **Raw Sienna** on a diagonal across the top to form rim as needed. Overstroke with **Camel**.

Optional: Shade the basket with **Glazing Medium** in the heel of your brush and **Burnt Umber** in the tip across the ends of each weave and under the rim.

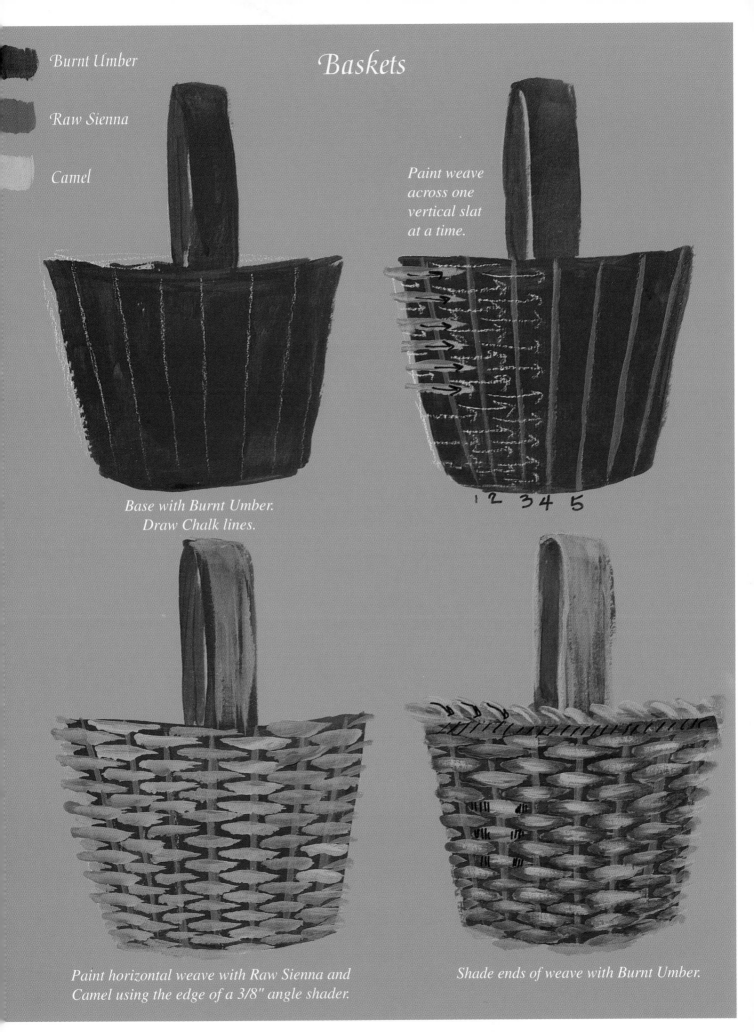

Burnt Umber

Raw Sienna

Camel

Baskets

Paint weave
across one
vertical slat
at a time.

Base with Burnt Umber.
Draw Chalk lines.

1 2 3 4 5

Paint horizontal weave with Raw Sienna and
Camel using the edge of a 3/8" angle shader.

Shade ends of weave with Burnt Umber.

Leaves

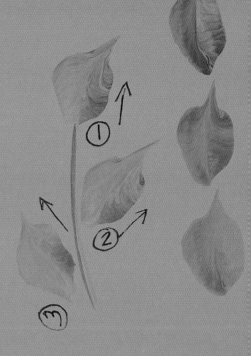

Avocado

Evergreen

Blue Mist

Olive Green

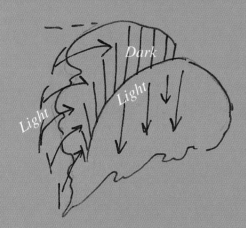

Dark

Light

Light

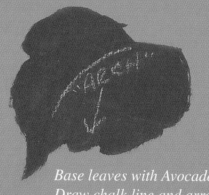

Base leaves with Avocado.
Draw chalk line and arrow.

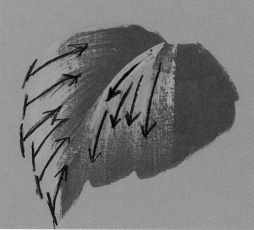

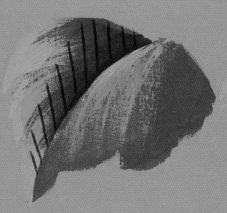

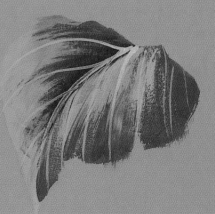

Squishy Leaves

These leaves are called "squishy" because you create them by squishing the paint from underneath your brush. Paint "squishy" leaves using flat shaders. The size of your brush determines the size of the leaf. I usually use #12 flat shader for the larger leaves and a #6 or#8 for smaller leaves.

*Load your brush by dipping into **Glazing Medium**, and then lay the whole brush flat into the edge of **Avocado, Evergreen, Olive Green & Blue Mist** flipping the brush over to load both sides. The brush will look like a mingled mess.*

*Position the brush as if it were resting on a baseball diamond. Place the heel of your brush at home plate and lay the edge of your brush along the line between home plate and third base (left handed people line up along the first base line). Hold the brush with the handle out to the right if you are right handed and out to the left if you are left handed. Push down on the brush all the way to the ferrule. Give the brush a 1/4 turn to the right (left if left handed) and stand the handle up in the center of the blob and slide forward to second base to create the vein and the tip of the leaf. Pull back a stem with the edge of your brush and add another leaf on the right and one on the left to form a spray of three leaves. Without picking up more paint, touch your brush into **Glazing Medium** to create more transparent leaves. Try adding a little **Emperor's Gold** to your basic green. Often I pick up a bit of my flower colors to add interest. Practice, Practice, Practice!*

Basic Leaves

*Paint these leaves with 1/2" angle shader using the basic greens. Base in loose triangular shapes with **Avocado** and let dry. Draw a curved line toward the tip of the leaf with a white chalk pencil. Think of this curved line as forming an "Arch" Draw an arrow under the arch to help you plan the direction to flick your brush. Pull the edge of your brush through the edge of **Olive Green** (to open hairs). Draw a line on top of your chalk line and with the handle of your brush straight up flick several strokes the direction of the arrow. Draw arrow on the opposite side of the leaf and now flick back from the point in the same manner using first **Olive Green** and then **Blue Mist**. Dip heel of your brush into **Glazing Medium** and pull the point across the edge of **Evergreen** and glaze the area next to the vein darker. Paint veins with **Olive Green** and a touch of **White** using a little water and your liner brush.*

Branches, Berries, Squishies

Paint branches using your liner brush. Load brush fully with **Faux Glazing Medium, Burnt Umber** and **Emperor's Gold**. Mingle color in brush to load and roll back to a point. Start branch at largest end, apply pressure, & pull toward smaller branches. Wiggle your brush slightly as you pull to create small twigs.

Paint squishy leaves on branches. Start with your #12 flat shader. Paint the first leaf away from the big end of the branch and then pull back a stem using the color in your brush and edge of your brush. Paint another leaf to the right and another to the left to form a 3-leaf spray. Pick up extra glaze in your brush and paint more 3-leaf sprays. Paint some smaller leaves on the tips of some of your branches using your #6 flat shader.

Paint berries with a cotton swab. It works great for blackberries, raspberries, holly berries, small grapes, pyracantha berries, and bittersweet. Let your imagination work for you. For smaller berries pull some cotton off the end of your swab. (Inexpensive cotton swabs work great as they usually have a bit less cotton the tip.) Touch cotton swab into **Faux Glazing Medium** and roll the tip in your fingers to reshape it before tapping in the paint. Touch one edge into a color and touch the other edge into another color. Touch the loaded cotton swab on the surface to form berry. A hole should form in the middle of the berry. As the swab gets ragged on the edges, roll the edges back into shape on the palette. My little granddaughter, Paige, loves to use her finger so now I also paint "finger berries". To create large berries try tapping into paint with the ends of wooden dowels of various sizes. Be generous with your paint & tap into various colors.

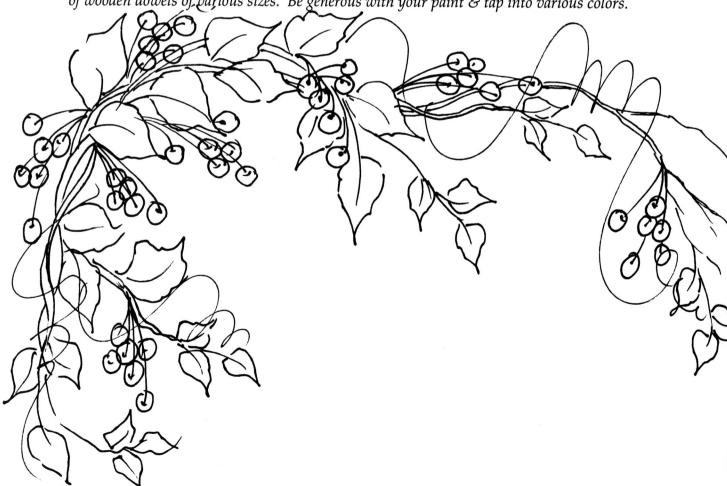

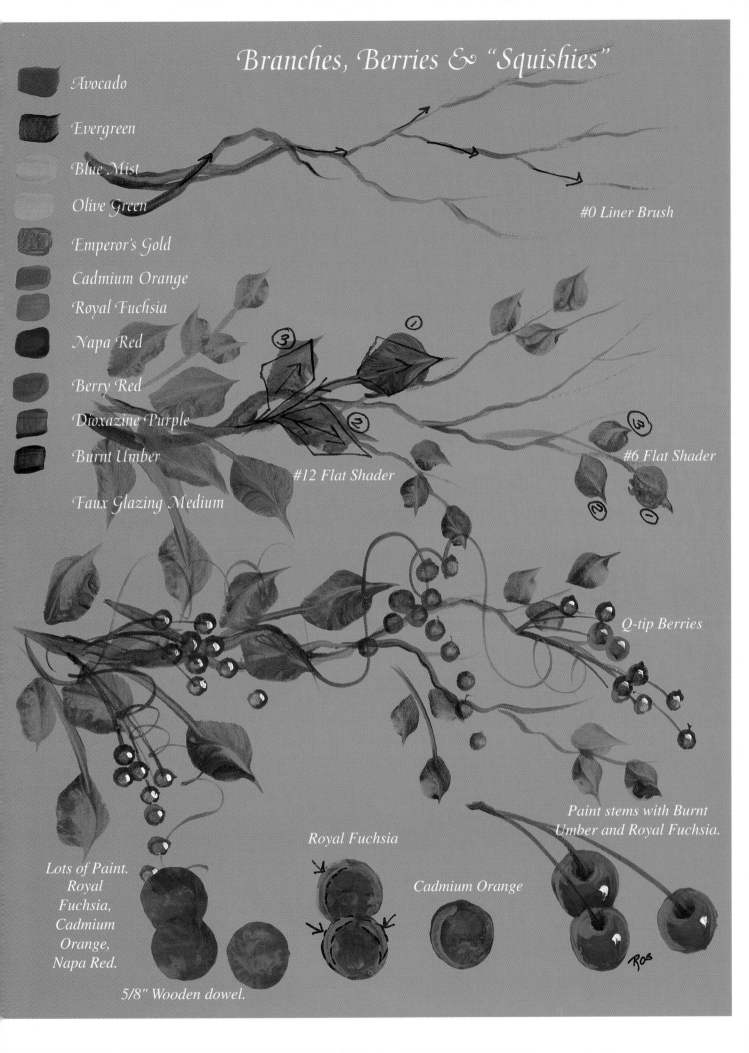

Branches, Berries & "Squishies"

Avocado

Evergreen

Blue Mist

Olive Green

Emperor's Gold

Cadmium Orange

Royal Fuchsia

Napa Red

Berry Red

Dioxazine Purple

Burnt Umber

Faux Glazing Medium

#0 Liner Brush

③

①

②

③

②

①

#12 Flat Shader

#6 Flat Shader

Q-tip Berries

Paint stems with Burnt Umber and Royal Fuchsia.

Royal Fuchsia

Lots of Paint. Royal Fuchsia, Cadmium Orange, Napa Red.

Cadmium Orange

5/8" Wooden dowel.

Ros

Daises

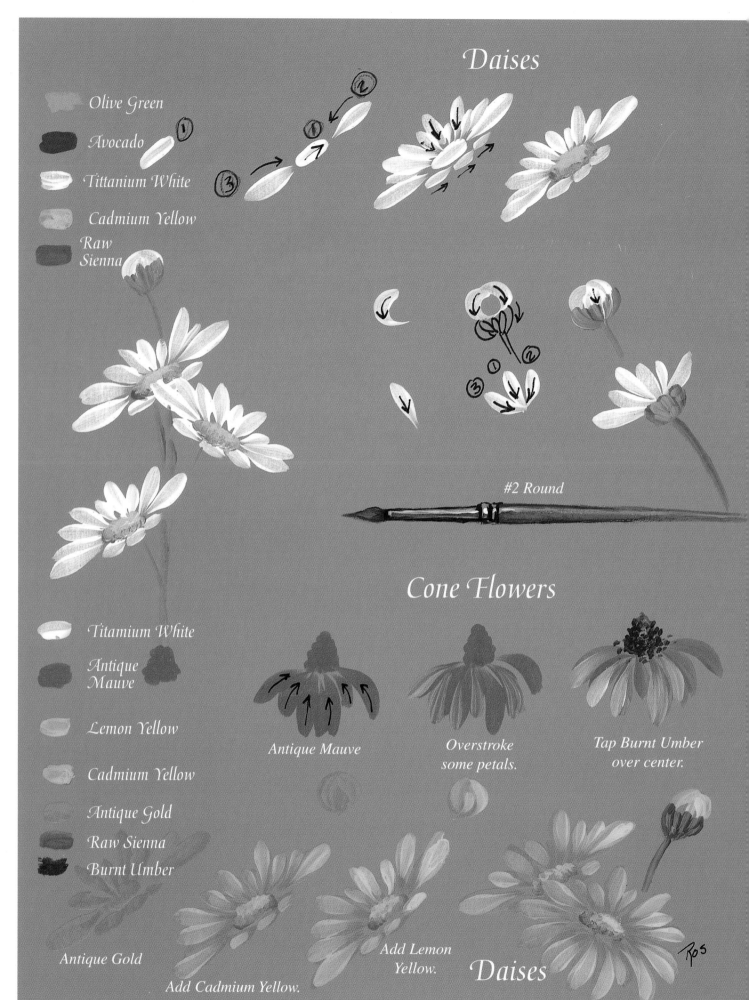

Olive Green

Avocado

Tittanium White

Cadmium Yellow

Raw Sienna

#2 Round

Cone Flowers

Titamium White

Antique Mauve

Lemon Yellow

Cadmium Yellow

Antique Gold

Raw Sienna

Burnt Umber

Antique Mauve

Overstroke some petals.

Tap Burnt Umber over center.

Antique Gold

Add Cadmium Yellow.

Add Lemon Yellow.

Daises

Ros

Painting Flowers

I fill my brush full so that I can stroke & tap with a light touch to achieve a delicate look.

*Practice the flowers on **"Write On" Transparency Film** (Office Supply stores). Paint over the worksheet in the books by placing the piece of film on top. Make a notebook of your own flower studies.*

*Paint background foliage first with **Avocado, Evergreen, Olive Green, & Blue Mist**. Let it dry. Pattern or sketch with a white chalk pencil on top of the foliage. Try painting these flowers using your pattern only as a visual guide for positioning. Paint main flowers next, add leaves, filler flowers, stem & squiggles. Put these flowers together as they please you. Remember you are painting your own gardens or arranging flowers in your favorite vase. Test colors first on transparency film & lay on top to check color & position. Try out colors on a jar or tin can.*

Daisies

Pull your round brush through the puddle of paint several times to load the brush and pull the tip of the brush back to a point. Paint the center first. Stand the handle of your brush straight up. Touch the tip of your brush on the tip of the petal, apply pressure and pull the stroke toward the center of the daisy. Gently release pressure as you pull the stroke. Pick up paint often as the ridges formed on the edge of the petal have texture and makes the petal appear more realistic. Paint the longest petals next to create a graceful oval shape. Fill in the center back and the rest of the petals with more strokes. Vary the lengths of petals to keep a loose look.

White Daisies *- Paint centers and petals with **Titanium White** using the tip of your #2 round brush. Tap over flower center with **Cadmium Yellow Medium** using the tip of your round. Shade the center by tapping along the bottom with **Raw Sienna**.*

Yellow Daisies *- Paint center and petals with **Antique Gold** using the tip of your # 2 round brush. Allow to dry. Overstroke center and each petal with **Cadmium Yellow**. Lift your brush and leave a little of the **Antique Gold** showing near the center. Overstroke a few petals on the right side of the flower with **Lemon Yellow** to add a little extra "zing." Tap the centers with **Cadmium Yellow** and add taps of **Raw Sienna** to shade at the bottom.*

Cone Flowers

*Paint Cone Flowers by tapping the center and pulling hanging down petals with **Antique Mauve** and **Antique Mauve** and **White** using #2 round brush. Tap over the center with **Burnt Umber** leaving some of the **Antique Mauve** showing at the top. Add a few extra taps with **Burnt Umber** and the tip of your liner brush at the base of the center and on some of the petals.*

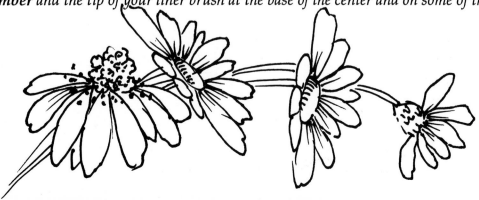

Geraniums

*Paint Geranium leaves a circular shape with a notch using **Avocado** and a 1/2" oval brush. While still wet, overstroke edges with **Olive Green**. Pull your brush flatting it in the edge of **Olive Green** making the hairs fan out as wide as possible. Stand the handle straight up in the air, using your little finger resting on the paper for balance, set the brush outside the edge and swing up with a flicking motion. Paint overlapping strokes with a light pressure that does not bend the hairs of the brush. Paint turned leaf like an irregular 1/2 circle with **Blue Mist** in back and create turned edges in the front with **Olive Green**. Paint full leaves in the front first and the rest will be only partial leaves. Position is not important as flowers will cover most of these leaves.*

*Paint Geranium flowers by dabbing an irregular blob of **Cadmium Orange, Jack o' Lantern Orange** and **Royal Fuchsia** using the backside of your #8 filbert brush. While still wet, paint four petal flowers by pulling your color filled filbert brush through the edge of White. Paint flowers on top and radiating over the edge of the blob and leaving some open spaces. Add stems with **Olive Green** or **Avocado** using your liner brush.*

*Paint buds with the chisel edge of your filbert using the flower color. Add calyx with **Avocado** and **Olive Green** using little strokes like the buds to form a half circle. Add little green stems with your liner and little strokes to connect the buds to the stems.*

*Pink Geraniums - **Antique Mauve, Royal Fuchsia** and **White**.*

*Red Geraniums - **Napa Red, Berry Red, Cadmium Orange** and **Jack o' Lantern Orange**.*

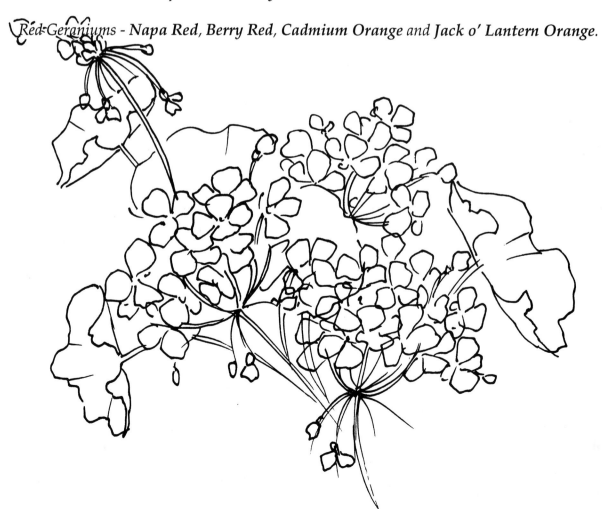

Geranium Leaves & Flowers

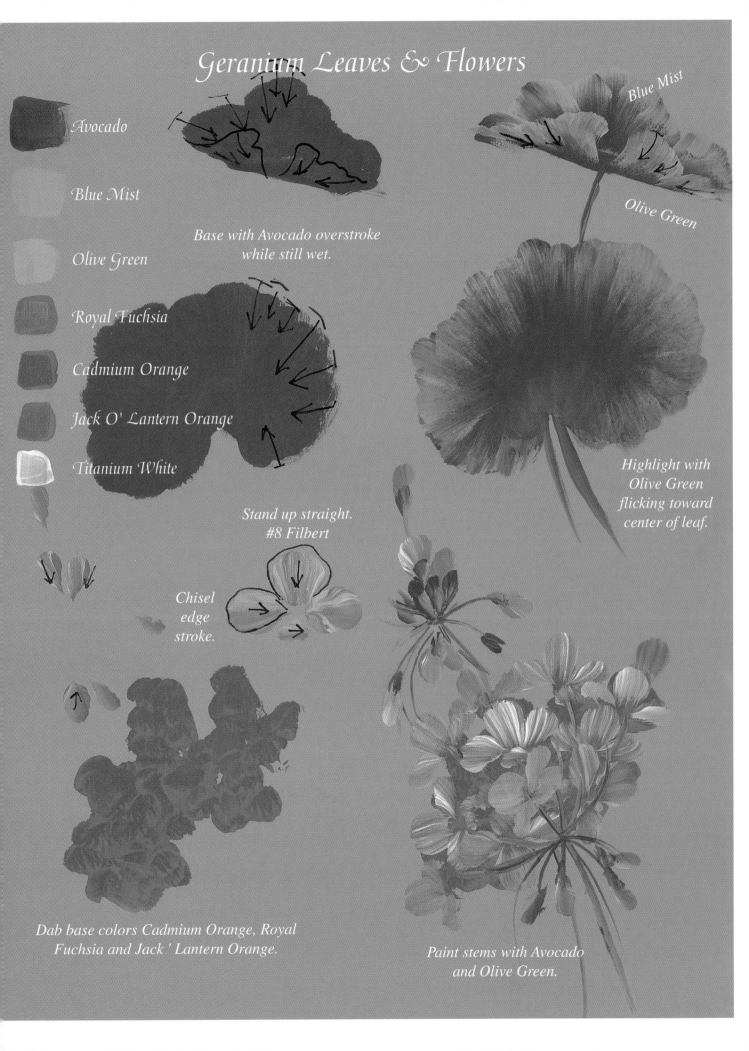

Avocado

Blue Mist

Olive Green

Royal Fuchsia

Cadmium Orange

Jack O' Lantern Orange

Titanium White

Base with Avocado overstroke
while still wet.

Blue Mist

Olive Green

Highlight with
Olive Green
flicking toward
center of leaf.

Stand up straight.
#8 Filbert

Chisel
edge
stroke.

Dab base colors Cadmium Orange, Royal
Fuchsia and Jack ' Lantern Orange.

Paint stems with Avocado
and Olive Green.

Poppies

Berry Red

Royal Fuchsia

Cadmium Orange

Jack O' Lantern Orange

Avocado

Olive Green

Blue Mist

Titanium White

Paynes Grey

Dioxazine Purple

"Bud"

1/2" Oval Wash Brush

Base one petal "flick" back from edge toward center.

Base buds and seed pods with Olive Green. Shade with Avocado and Blue Mist. Add dots with Cadmium Yellow.

Oriental Poppies

Paint one poppy petal with **Cadmium Orange & Royal Fuchsia**, using 1/2" oval brush. While the petal is still wet, flick overlapping strokes from over the edge of the petal toward the center of the flower. Paint with your dirty brush flattening and pulling it in the edge of your **White** paint. Load brush by pulling and flattening the hairs to make them as wide as possible. Vary the colors by picking up **White, Jack O' Lantern Orange & Cadmium Orange** from the edge of the various colors. Stand the handle of your brush straight up in the air and use your little finger for balance. Swing brush up rather than pull down to create "hairy" edges as you lift. Paint with a light touch so as not to bend the hairs of the brush. Let dry, then deepen the color around the center & between petals with a corner loaded 1/2" angle shader using **Glazing Medium** in the heel of brush & **Berry Red** in the point. Note direction of strokes where petals overlap.

Paint the center of the flower with **Olive Green**. Shade along the bottom edge and around the middle with **Avocado**. Paint little lines radiating from a central point with **Olive Green** mixed with a little **White** and water using your liner brush.

Paint pigmented area on the petals with **Dioxazine Purple** and **Paynes Grey** using the chisel edge of your 1/2" angle shader. Paint lines & dots completely around the center with **Dioxazine Purple & Paynes Grey** using a liner brush. Add more lines and dots with **Olive Green**.

Icelandic Poppies: Vary colors by basecoating some with **Royal Fuchsia**, some with **Berry Red**, and some with **Cadmium Orange**.

Yellow Poppies: Base Yellow Poppies with **Cadmium Yellow** and **Antique Gold**. Highlight with **Pineapple**.

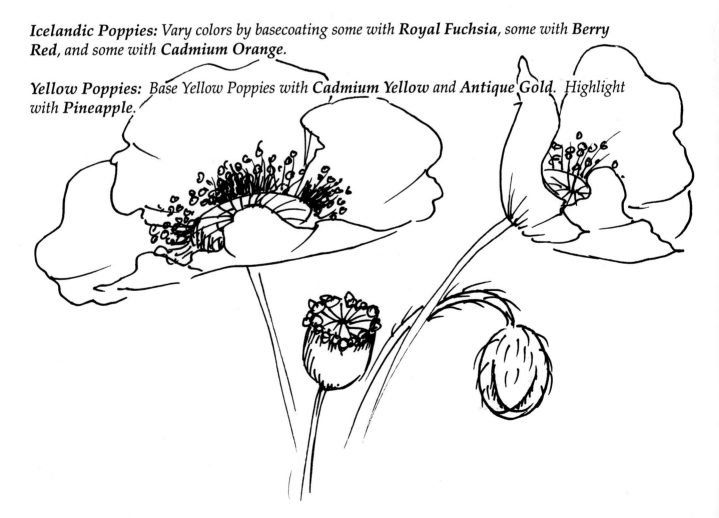

Pansies

*Paint Pansies with 1/2" angle shader using the color of choice. I painted these pansies with **Cadmium Yellow** and **White**. Base loose oval shape with **Cadmium Yellow** and let dry.*

*Pansies have five petals. Start with the two in the back and highlight with a double loaded brush with **Cadmium Yellow** and **White**. Brush along the outer edge using lots of paint to create a ridge on the edge with **White**. Now paint lower center petal. Paint last petals on each side keeping them nice and round with slightly ruffled edges. Let dry and tap dark faces on the flowers with the edge of your brush using **Dioxazine Purple** and **Paynes Grey**. Paint little **Olive Green** noses in the center of the petals.*

Paint Pansy leaves similar to "basic leaves" but a little longer and with rounded tips.

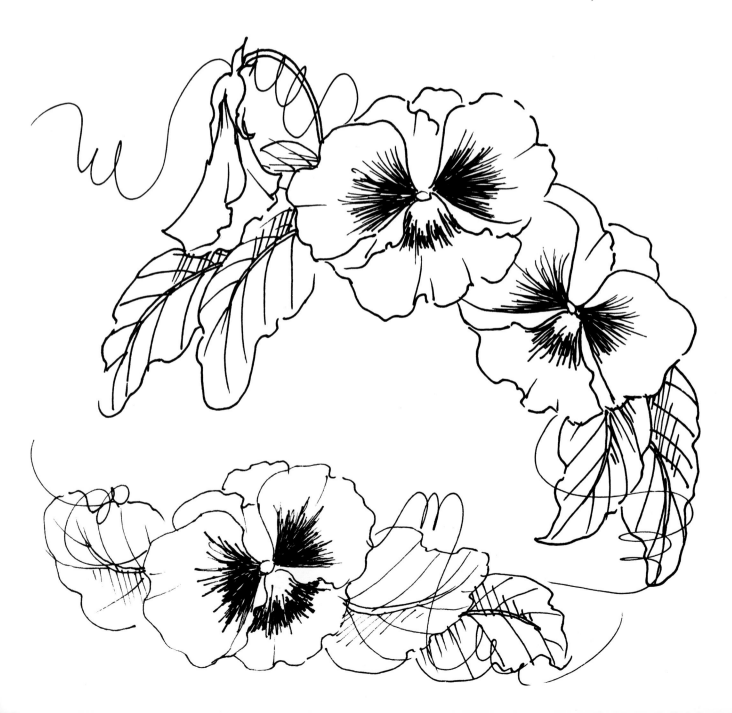

Pansies

Cadmium Yellow

Dioxazine
Purple

Titanium White

Paynes Grey

Avocado

Evergreen

Olive

Blue
Mist

Start with Cadmium Yellow Oval.

Double loaded 1/2" Angle Shader

Base leaves with Avocado.

Queen Ann's Lace

Titamium White

Lemon Yellow

Olive Green

Blue Mist

Add Blue Mist
at bottom.

Tap Olive Green.

Tap Lemon Yellow.

*Tap Titanium
White.*

*Add dots with White. Add stems
with Olive Green and highlight with
Lemon Yellow.*

Queen Anne's Lace

Position your flowers by drawing with a chalk pencil. Place your flowers irregularly with some touching each other. Vary the size spacing and angles.

Tap all of your flower at one time. Tap Queen Anne's Lace with your 3/4" foliage brush using lots of paint and a very light touch. First tap a loose line of **Olive Green** for each flower. Tap a few small balls to form finished flowers.

Tap a little **Blue Mist** along the bottom of the **Olive Green**. Tap **Lemon Yellow** on the upper left of each flower. Now clean out your brush and dry it. Tap into the edge of your **White** paint and touch lightly on top of the **Lemon Yellow** and **Olive Green** but not on top of the **Blue Mist**. Turn your brush different directions to leave different shapes in your little blobs of paint. Make the edges ragged and leave some of the colors underneath showing. Add a few dots with the tip of your #2 round. Paint stems with **Olive Green** and accent them on the left side with **Lemon Yellow**.

Spatter with **White** mixed with water using your foliage brush. Hold the handle straight up and flick the hairs lightly with your finger. Test on your palette to see what your spatter looks like. If the paint does not spatter, you need to add more water to your mix.

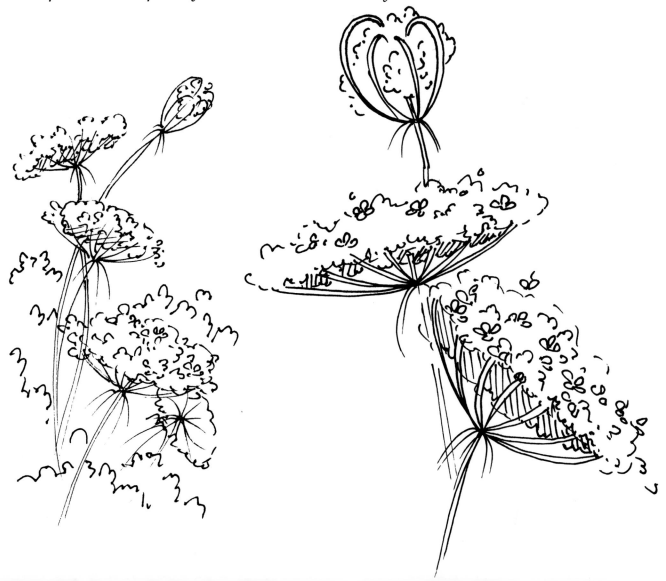

Iris

*Pull Iris leaves with your #2 round brush using **Blue Mist**, **Avocado**, **Evergreen**, **Olive Green**, and **Faux Glazing Medium**. Pull your brush through various green colors, plus **Blue Mist** and **Faux Glazing Medium** and pull up wide, grass like, strokes.*

*Pull the #6 filbert brush through **Dioxazine Purple** and **White** to create "streaky" color. Lay a piece of transparency film on top of work sheet and practice strokes. Top right petal; hold the brush on a 45-degree angle and press down, now lift to edge of brush and pull down. Keep your brush in the same position and let the brush do the work for you. The left strokes overlap the right to form the opposite side. Center petal; hold the brush straight, mash down and fan hairs, pull up and slide brush to chisel edge. Side petals; pull comma stroke, lift and slide toward center of flower, overlap with second petal. Paint beards with dots of **Cadmium Yellow**.*

Daffodils

Paint leaves similar to Iris leaves but pick up first one color, then another and paint more strokes.

*Paint trumpet of flowers with **Antique Gold**. Note uneven spacing place some pointing up and some pointing down. Paint petals around the base of trumpet with **Cadmium Yellow** using your #2 round brush. Paint row of sloppy dots and overstroke center of trumpet with **Cadmium Yellow** using your liner brush. Use lots of paint to create ridges and bright color. Paint stems with **Olive Green**. Highlight trumpets and petals on the right side with **Lemon Yellow** using your liner brush.*

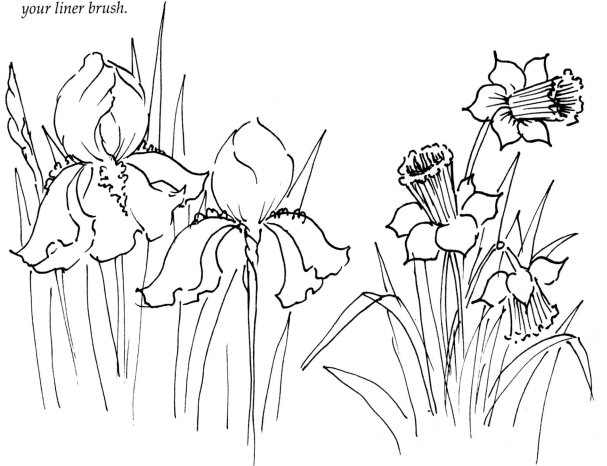

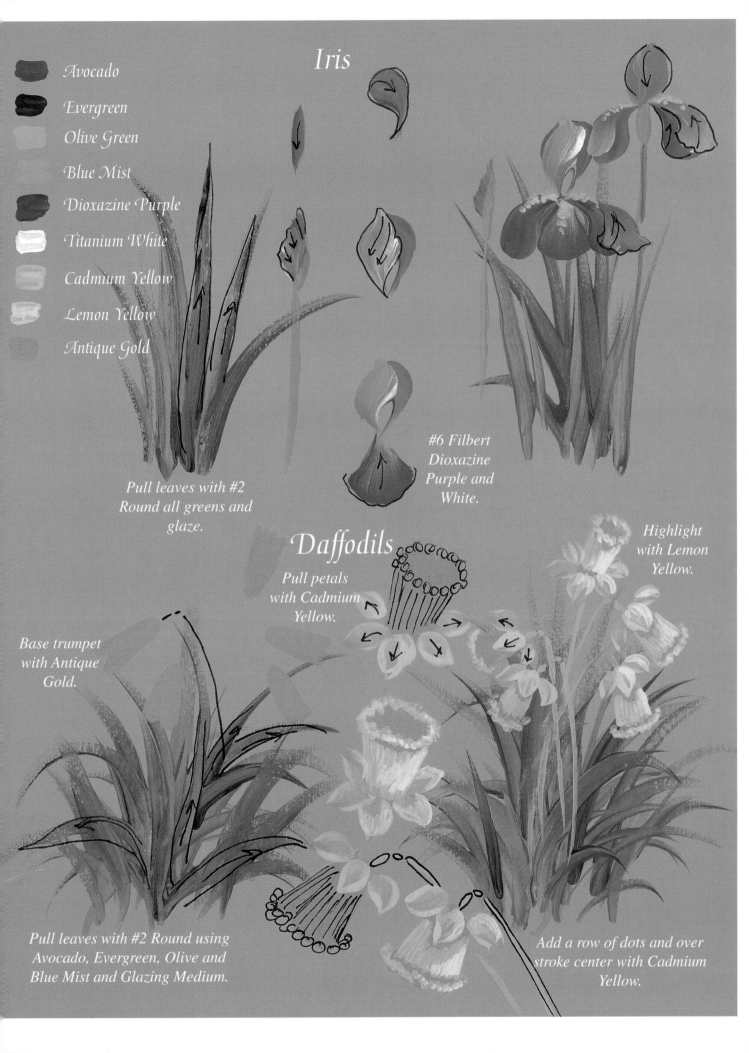

Iris

Avocado
Evergreen
Olive Green
Blue Mist
Dioxazine Purple
Titanium White
Cadmium Yellow
Lemon Yellow
Antique Gold

Pull leaves with #2
Round all greens and
glaze.

#6 Filbert
Dioxazine
Purple and
White.

Daffodils

Pull petals
with Cadmium
Yellow.

Highlight
with Lemon
Yellow.

Base trumpet
with Antique
Gold.

Pull leaves with #2 Round using
Avocado, Evergreen, Olive and
Blue Mist and Glazing Medium.

Add a row of dots and over
stroke center with Cadmium
Yellow.

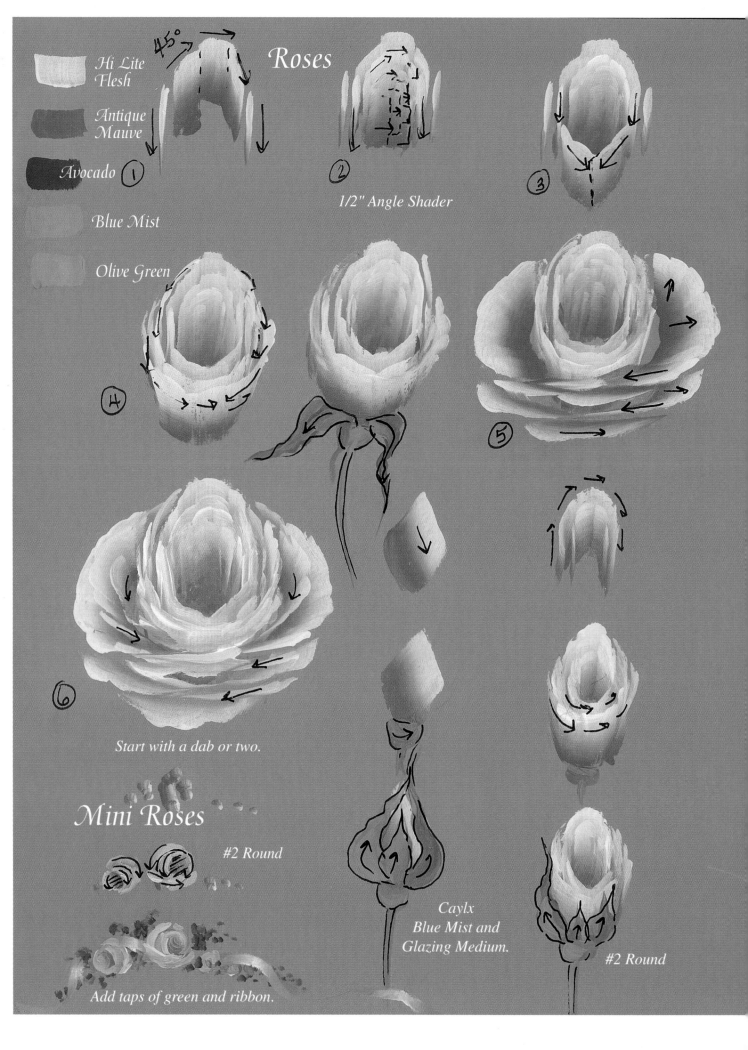

Hi Lite Flesh

Antique Mauve

Avocado

Blue Mist

Olive Green

45°

Roses

① ② ③

1/2" Angle Shader

④ ⑤

⑥

Start with a dab or two.

Mini Roses

#2 Round

Add taps of green and ribbon.

Caylx
Blue Mist and
Glazing Medium.

#2 Round

Roses

I found I liked my roses best when I paint them with simple loose shapes. If they get too fussy I just mess them up a bit. Lay a piece of transparency film on top of worksheet and paint each step. Paint only buds until you get that inner part to please you. Most of my designs are all buds or with only one or two open roses.

*The way you load your brush and pick up your colors is the secret to painting beautiful roses. It is best to work on a wet palette using Deli Wrap so that the mix you create will stay fresh and you do not add extra water to your colors. It is necessary to have enough room to be able to lay your brush flat in the edge of your light value without running into another color. Load your brush by touching the heel into **Antique Mauve** and the tip of the brush into **Hi Lite Flesh** (double loaded brush). Stroke flat down only, using approximately 1" long strokes, several times on your palette across the edge of the light value until you create a mix between the two colors. Pick up color in the same place every time. You will have enough paint in your brush so that the color goes through the brush so there is no need to work the brush both directions. Pick up the darker value only once in the middle of the flower and work from the mix the rest of the time sliding toward the lighter value. Pick up fresh paint for every petal and sometimes for every stroke.*

Hold the brush horizontal with the tip up, the heel down and the handle out to the right (left if you are left handed). Lock your fingers and wrist and move your whole arm keeping the brush in the same position. Row 1 Pull a line down with the edge of your brush on both sides of the flower, this is the edge of your cup/bud, these will be your connecting strokes as you work down and these strokes should show. Leave a tiny space inside and stroke up, across and down to create a petal. Lay your brush flat so that you are using the back instead of just the edge. Use lots of paint and very light touch. Paint two rows of petal inside of the cup of the flower & two rows on the outside. Lift your brush and set it back down to give the illusion of many petals instead of just one large petal. Paint extra rows around the outside to create a more open looking rose.

*Paint calyxes and stems on rose buds with **Glazing Medium**, **Avocado** and **Blue Mist** using your #2 round brush.*

Creamy Roses - Buttermilk, Raw Sienna & White.

Yellow Roses - Antique Gold, Pineapple & White.

Hollyhocks

*I usually paint Hollyhocks growing in a garden. Smaller flowers in a distant scene and larger flowers in the foreground. Start by pulling up some suggestions of stems with **Avocado, Olive Green** and **Blue Mist** with **Glazing Medium** using your liner brush. Place oval blobs and dot with **Antique Mauve** and **White** using your #2 round. Mingle your color by picking up both colors and stirring around a bit. Deepen the centers of the blobs by picking up more **Antique Mauve** on your dirty brush and paint a curved stroke in the center. Pick up more **White** and mingle to create a lighter value of pink and paint a loose circle around the outside edge. Paint a little row of **Cadmium Yellow** dots using the tip of your liner brush to create stamens.*

*Paint large dots with a mix of **Blue Mist, Olive Green** and **White** with the tip of your #2 round brush. Then create the illusion of buds and seedpods all up and down the stems. Dab a suggestion of loose triangular leaves with **Avocado, Evergreen,** and **Blue Mist**. Start these at the stem between the flowers. If you have too many flowers simply cover some up with leaves.*

*Paint a larger blob for the big flowers using your #8 Filbert. Deepen the center by picking up more **Antique Mauve** on one edge of your brush. Place the edge with the extra color at the bottom and brush across to create the darker area in the center of the flower. Pull your filbert brush flat in the edge of **White** paint and stand it up tall and flick overlapping strokes toward the center from the edges. This is that "Swing Up" motion so that you stop with ragged streaks on the inside of the flower. Paint stems with **Avocado** and **Olive Green** using your #2 round. Add some dabs for bud and seedpods with the edge of your filbert. Paint some small basic leaves with **Avocado, Evergreen, Olive Green** and **Blue Mist**.*

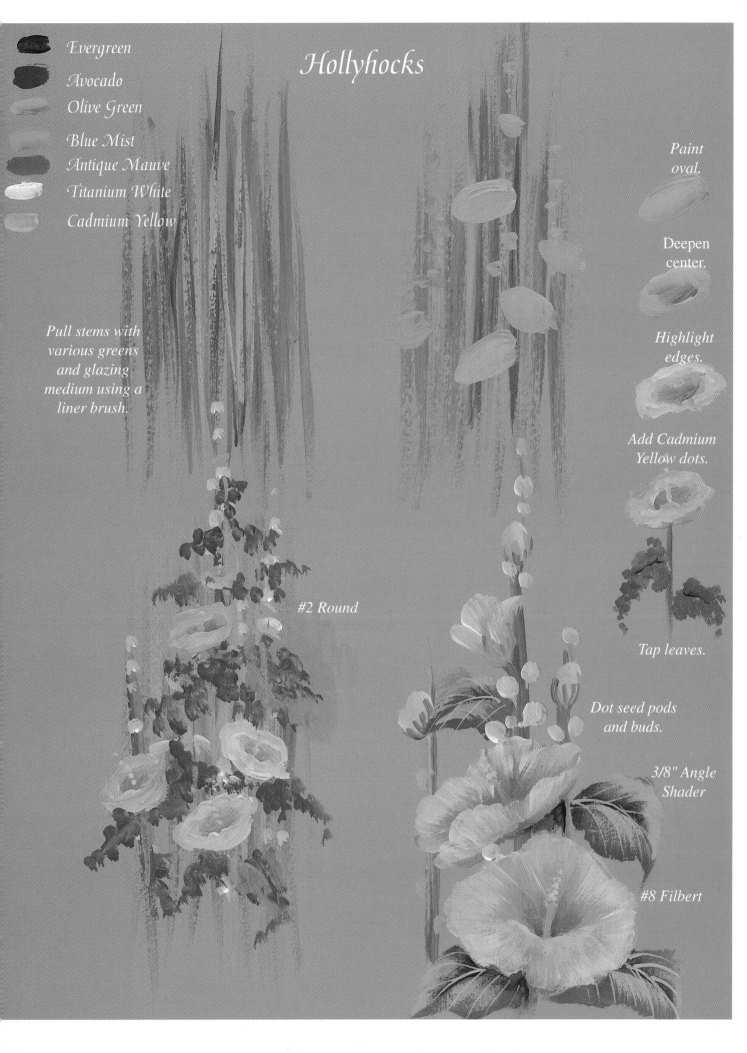

Hollyhocks

Evergreen

Avocado

Olive Green

Blue Mist

Antique Mauve

Titanium White

Cadmium Yellow

Pull stems with various greens and glazing medium using a liner brush.

#2 Round

Paint oval.

Deepen center.

Highlight edges.

Add Cadmium Yellow dots.

Tap leaves.

Dot seed pods and buds.

3/8" Angle Shader

#8 Filbert

Sunflowers

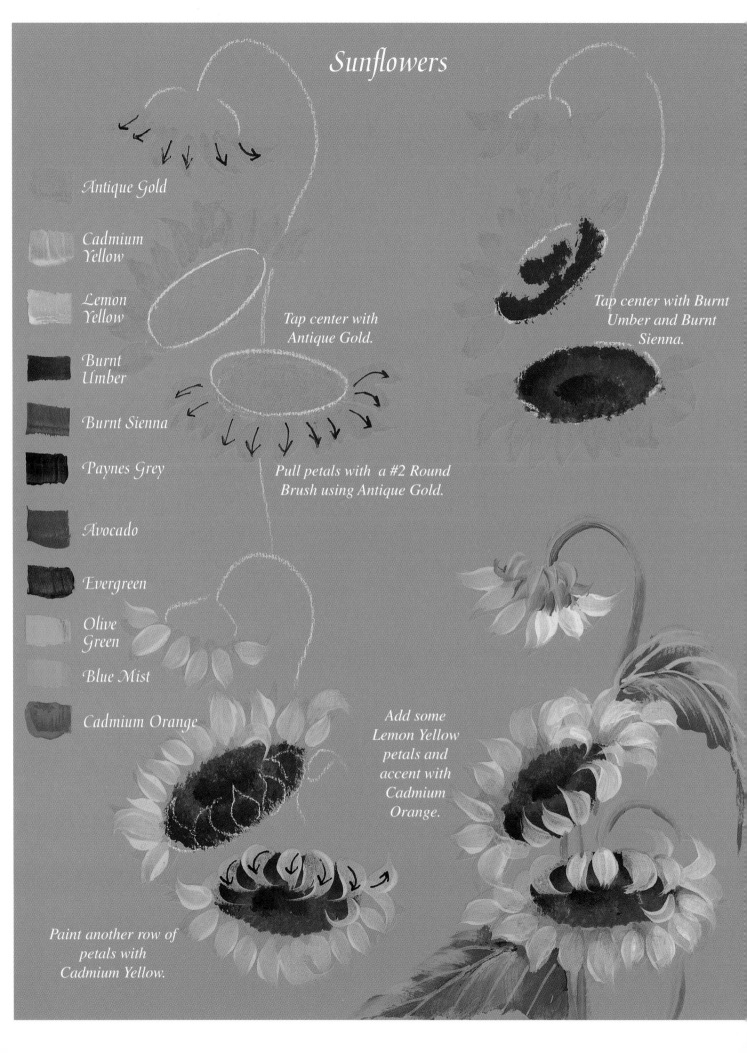

Antique Gold

Cadmium Yellow

Lemon Yellow

Burnt Umber

Burnt Sienna

Paynes Grey

Avocado

Evergreen

Olive Green

Blue Mist

Cadmium Orange

Tap center with Antique Gold.

Pull petals with a #2 Round Brush using Antique Gold.

Tap center with Burnt Umber and Burnt Sienna.

Add some Lemon Yellow petals and accent with Cadmium Orange.

Paint another row of petals with Cadmium Yellow.

Sunflowers

*Tap sunflower centers with **Antique Gold** using just the tip of your 1/2" foliage brush. Pull petals from the center out with **Antique Gold** using a #2 round brush. Stand your handle up nice and tall and apply pressure and give a little lift to create a point on the end of the petal. Use lots of paint to create ridges in the petals. Paint larger sunflowers with a larger round brush or use two strokes for each petal. Leave one side without petals to tip flowers a different direction.*

*Tap **Burnt Umber** along the bottom edge and in the middle of the center. Tap **Burnt Sienna** around the rest of the center leaving a little of the **Antique Gold** showing near the top. Add a little **Paynes Grey** on the left side of the **Burnt Umber** areas to deepen the color.*

*Paint another row of petals with **Cadmium Yellow**. Pull some petals over the center cupping them toward the center. Place some petals out of order to give the illusion that the petals twist and turn. Accent some petals on the right side with **Lemon Yellow**. Pick up **Glazing Medium** and a tiny bit of **Cadmium Orange** with a 1/2" angle shader to add a little accent color in a few places near the center. Paint stems with **Avocado** and **Olive Green**.*

*The leaves are large loose basic leaves painted with **Avocado**, **Evergreen**, **Olive Green** and **Blue Mist**.*

Lilacs

*Paint these flowers using a #4 filbert brush. Dab a base of color with **Dioxazine Purple** and **Blue Violet** using the flat of your #4 filbert brush. Keep the shape loose and "spikey". Pull the whole surface of the brush with the colors still in it through the edge of **White** & paint four petal flowers on top of the wet base of color. Paint the clusters of flowers at the stem end of the shape and only a few strokes at the tip, extend over the edges and leave some open spaces. Vary the color & shape of these cluster flowers. Paint more pastel flowers by using the paint still in your brush and picking up **Glazing Medium** for the basecoat. Pick up **White** paint and add some four-petal flowers on top.*

*Paint White Lilacs with **Olive Green** and **Glazing Medium** as your base color. Pick up **White** paint and paint 4 petal flowers on top. Add a few stems peeking through the petals with **Olive Green**. Paint some dots of **Olive Green** and **White** to create buds.*

Delphiniums

*Paint Delphinium in the same manner but with a tall spiky shape. These would be seen from a distance growing in a garden. Vary the colors between **Dioxazine Purple, Blue Violet, White** and **Glazing Medium**. Use **Olive Green** and **White** for white flowers. For tiny flowers use a #2 round and use your #4 filbert for larger flowers.*

Filler Flowers

Paint loose filler flowers in with other flowers in the same manner as lilac and delphiniums. Vary the colors to suit your design and to fill in the holes. These could be Forget-me-nots, Purple Salvia or anything that you want to call them.

Lilacs, Delphiniums & Filler Flowers

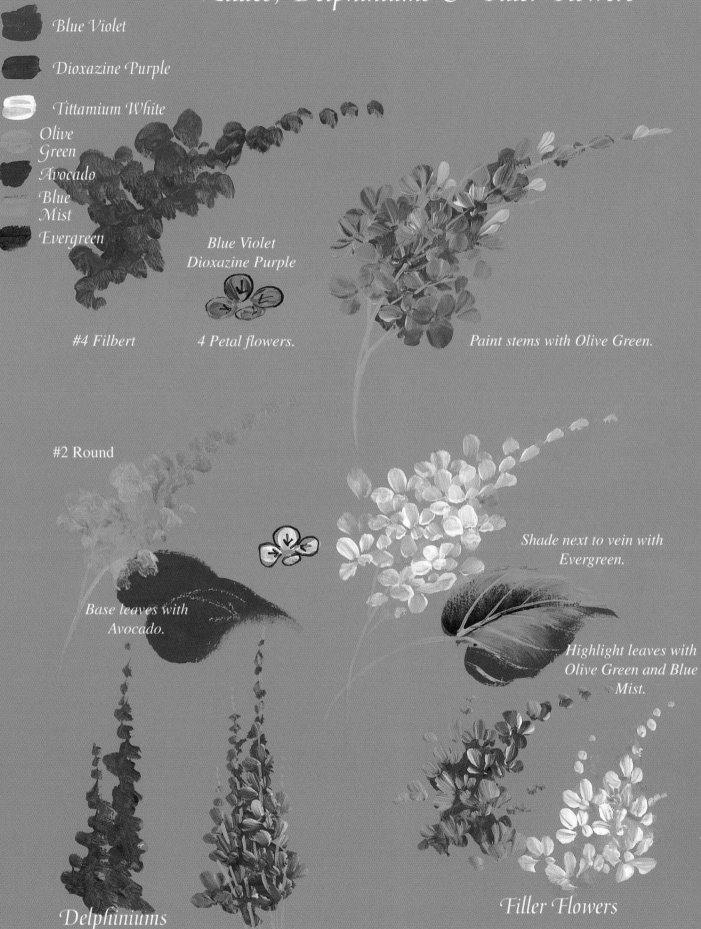

Blue Violet

Dioxazine Purple

Tittamium White

Olive Green

Avocado

Blue Mist

Evergreen

Blue Violet
Dioxazine Purple

#4 Filbert

4 Petal flowers.

Paint stems with Olive Green.

#2 Round

Shade next to vein with Evergreen.

Base leaves with Avocado.

Highlight leaves with Olive Green and Blue Mist.

Delphiniums

Filler Flowers

Tulips

Royal Fuchsia

Antique
Mauve

Titanium White

Avocado

Olive Green

Evergreen

Blue
Mist

Plum

Base tulips with Antique
Mauve and Royal Fuchsia.
While still wet pick up
Titanium White in dirty brush
and "flick" to create petals.

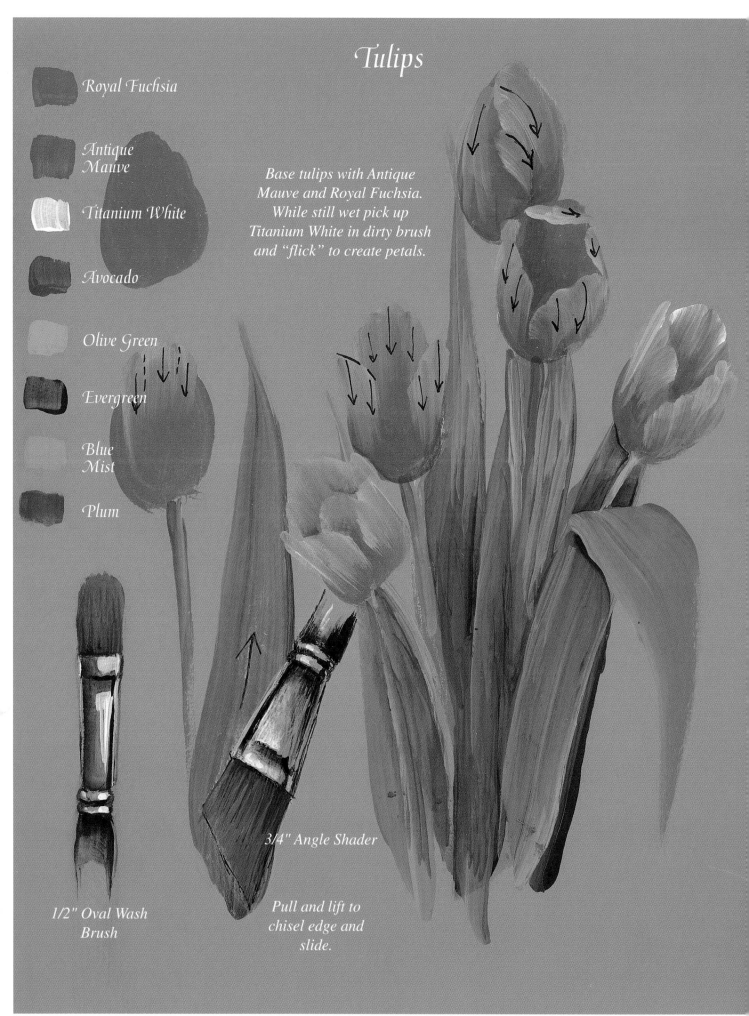

1/2" Oval Wash
Brush

3/4" Angle Shader

Pull and lift to
chisel edge and
slide.

Pink Tulips

Practice these flowers by placing a piece of "write on" transparency film on top of this worksheet.

Tulip leaves are fat blade shapes created by pulling up strokes with various shades of green and **Faux Glazing Medium.**

Base an egg shaped flower with 1/2" oval brush by pulling through **Royal Fuchsia** *and* **Antique Mauve.** *Highlight and create petals while the base is still wet. Pull your dirty oval brush in the edge of* **White** *paint pushing down on your palette to flatten and widen the hairs of the brush. Stand the handle of the brush straight up; touch the surface just above the top of the petal and flick by swinging up and toward you. Paint overlapping strokes straight toward the stem highlighting the edge only. Use such light pressure so as not to bend the hairs of the brush. Balance with your little finger to keep the pressure off the surface. Drop down and create the petals in front.*

When these flowers are dry, load your 1/2" angle shader with **Faux Glazing Medium** *in the heel and a little* **Plum** *in the point and glaze a little deeper value inside and at the bottom of the flowers. Paint stems from the bottom of the tulip town with* **Olive Green** *using your #2 round.*

Zinnias

*Paint these zinnias with lots and lots of paint. Think of the word "shovel" as the ridges in the generous paint will form the petals and the colors will dry vivid and bright. Start with the back row of the back section with **Napa Red** using your #6 filbert brush. Keep the handle of your brush straight up to form little round petals with ridges. Change colors mid-row by picking up **Berry Red** and then **Cadmium Orange** in your dirty brush. Paint three back rows before you go to outside front row. Now add **Bright Orange** and then **Cadmium Yellow**. If the color dries down too much add a few more petal when dry. Tap centers with 1/4" foliage brush with **Olive Green**. Tap a little **Avocado** in the center and along the bottom. Tap a little **Lemon Yellow** in the middle for highlight.*

Paint "basic" leaves, and add buds and calyxes .

Zinnias

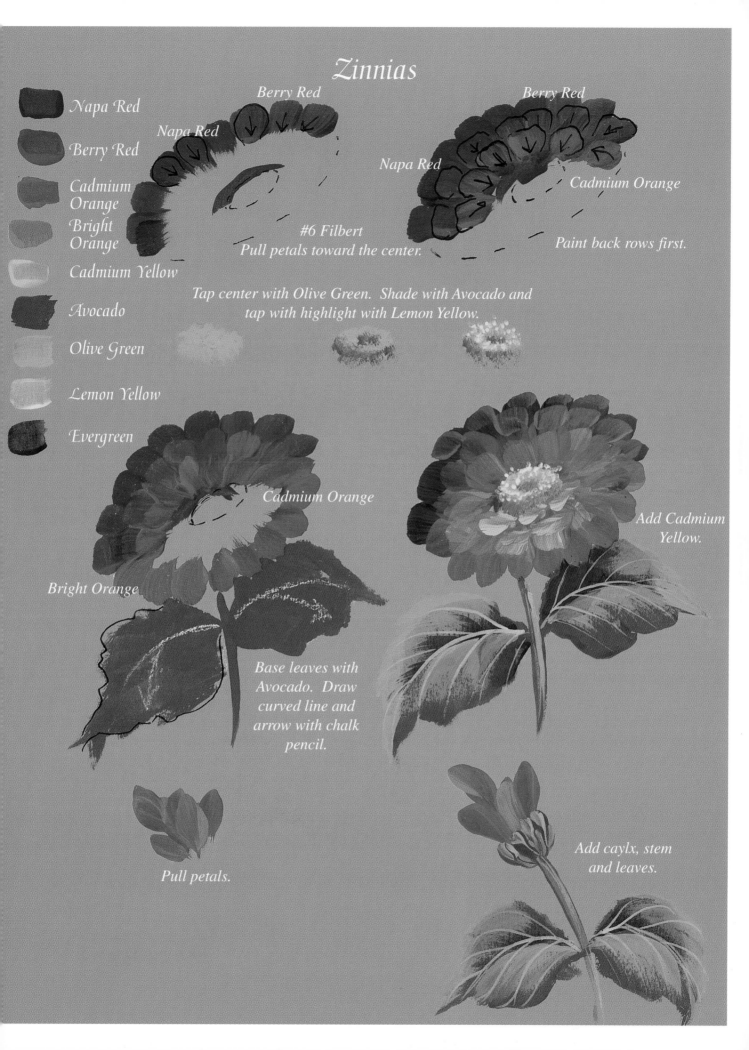

Napa Red

Berry Red

Cadmium Orange

Bright Orange

Cadmium Yellow

Avocado

Olive Green

Lemon Yellow

Evergreen

Berry Red

Napa Red

Berry Red

Napa Red

Cadmium Orange

#6 Filbert
Pull petals toward the center.

Paint back rows first.

Tap center with Olive Green. Shade with Avocado and
tap with highlight with Lemon Yellow.

Cadmium Orange

Add Cadmium
Yellow.

Bright Orange

Base leaves with
Avocado. Draw
curved line and
arrow with chalk
pencil.

Pull petals.

Add caylx, stem
and leaves.

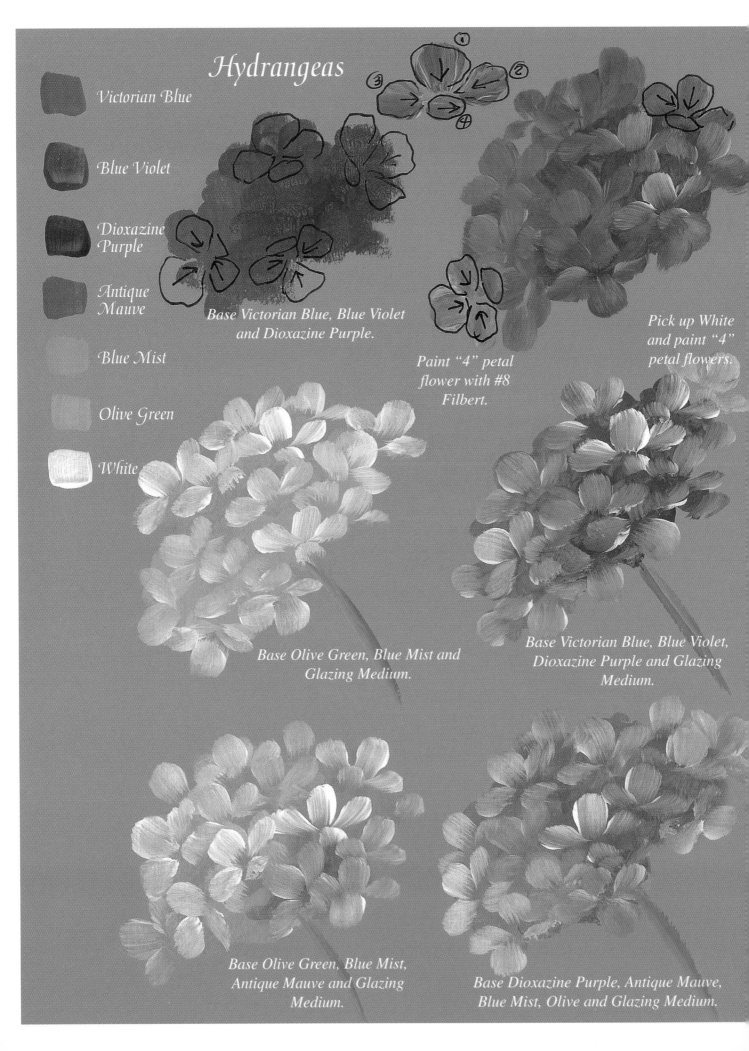

Hydrangeas

Victorian Blue

Blue Violet

Dioxazine Purple

Antique Mauve

Blue Mist

Olive Green

White

Base Victorian Blue, Blue Violet and Dioxazine Purple.

Paint "4" petal flower with #8 Filbert.

Pick up White and paint "4" petal flowers.

Base Olive Green, Blue Mist and Glazing Medium.

Base Victorian Blue, Blue Violet, Dioxazine Purple and Glazing Medium.

Base Olive Green, Blue Mist, Antique Mauve and Glazing Medium.

Base Dioxazine Purple, Antique Mauve, Blue Mist, Olive and Glazing Medium.

Hydrangeas

Lay a piece of transparency film on top of this worksheet to practice these flowers. When completed, you now have an overlay sheet that you can place over your background to help you check color and placement for your design. Experiment with new colors first on transparency film.

Hydrangea blossoms are large ball shaped flowers composed of clusters of four petal blossoms. The colors range from blue to pink to purple. In the fall they turn pink to gray green with tints of mauve. They dry beautifully.

*The brush size determines the size of the blooms. I usually paint them with a #8 filbert brush. Colors will be determined by the base colors that you start with. Dab an irregular oval with at least three colors. While this base is still wet, pull your dirty brush through **White** and create four petal blossoms on top. You will be picking up the wet paint from your base color so pick up fresh paint only two or three times. Extend over the edge of the base and place flowers radiating around the oval. For a transparent look pick up **Faux Glazing Medium** in your base colors. I have listed the colors that I most often use.*

*Blue Hydrangeas - **Blue Violet, Dioxazine Purple, Victorian Blue, White** and **Faux Glazing Medium**.*

*Pink Hydrangeas - **Antique Mauve, Dioxazine Purple, Blue Mist, Olive Green, White** and **Faux Glazing Medium**.*

*White Hydrangeas - **Olive Green, Blue Mist, White** and **Faux Glazing Medium**.*

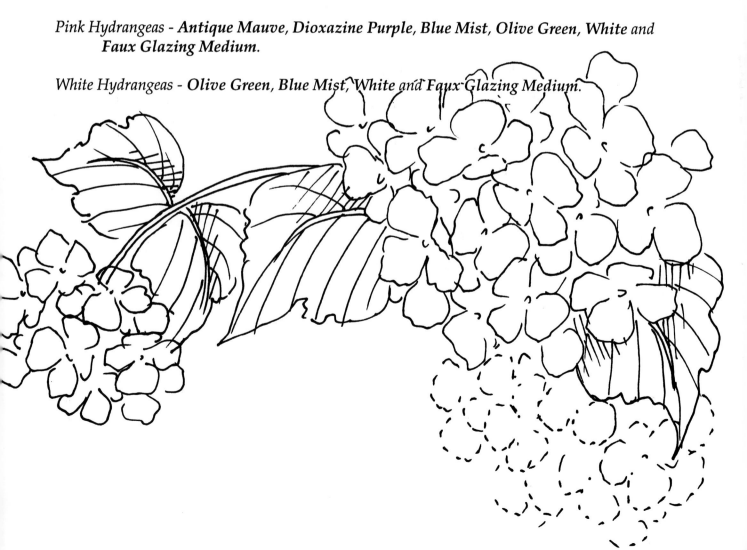

Painting Fruit Basics

Start all of the large fruits by painting a basecoat. Highlight the basecoat with **White** & the base color by loading the heel of 1/2" angle shader with **White** & the tip of the brush with the base color. Pat with the flat of the brush keeping the point of the brush with the base to the outer edge of the fruit. Allow colors to dry between layers. If you get carried away simply add some of the base color. Glaze fruits with **Faux Glazing Medium** in the heel of your brush & pigment in the point. Touch the heel of brush into **Glazing Medium** & slide the tip of brush across the edge of pigment a couple of times to load paint half way across the bristles. The first glazing color goes all the way around the fruit. Each color thereafter covers less of the area. Look closely at the color step-by-step directions.

Glaze over entire surface at least two times as you add layers, this will give depth to the fruit. Glazing medium does not extend the drying time. It can be removed by wiping off with water while it is still wet. Once a layer is dry the next layer will not lift the color. Paint each layer quickly, let dry & add another layer. If your paint begins to feel sticky allow to dry & add more layers. Sometimes you need to have a little more paint and glaze in your brush so that the surface dries slower. Learn to stop. Leave some of each color showing.

Pears

Undercoat pears with **White**. Paint with **Cadmium Yellow**. Let dry. Highlight the center top and bottom of the pear with double loaded 1/2" angle shader **White** and **Cadmium Yellow**.

Glaze first with **Antique Gold**. Progress to darker values using **Raw Sienna, Burnt Sienna, Cadmium Orange** and **Olive Green**. Strengthen highlight with dabs of **White** and **Lemon Yellow**. Paint stem with **Burnt Umber** and highlight with **Raw Sienna** and **White**. Spatter with **Emperors Gold**.

Pears

Titanium
White

Cadmium Yellow

Lemon Yellow

Antique Gold

Raw Sienna

Burnt Sienna

Burnt Umber

Cadmium Orange

Olive Green

Emporor's Gold

Undercoat
with
Titanium
White.

Base with Cadmium Yellow.

Highlight

Shade around pear with Antique Gold.

Deepen shading with Raw Sienna.

Add touches of Burnt Sienna.

Glaze with Cadmium Orange.

Glaze with Olive Green.

Paint stem. Add highlights
with Gold.

Royal Gala

Titanium White

Cadmium Yellow

Cadmium Orange

Berry Red

Napa Red

Olive Green

Avocado

Burnt Umber

Emperor's Gold

Undercoat with White. Base with Cadmium Yellow, Highlight with Titanium White.

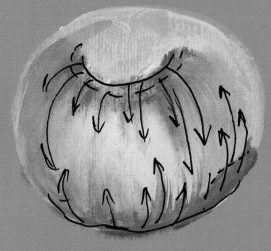

Wet with Water. Add line of Berry Red and pull down and up.

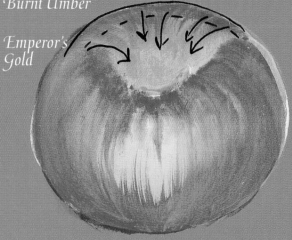

Wet area across the top and into core. Paint line of Berry Red, pull toward the core.

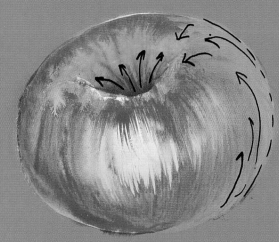

Re-wet. Paint Avocado in core and pull toward upper edge.

Glaze with Napa Red.

Spatter with Emperor's Gold. Paint stem with Burnt Umber. Add White highlights.

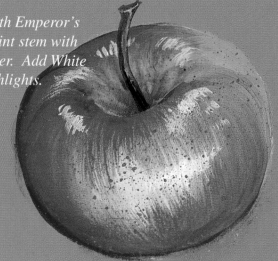

Royal Gala

Draw these apples like squatty circles with your chalk pencil. Undercoat Royal Gala apples with **White**. Basecoat with **Cadmium Yellow**. Let dry. Lighten the center by double loading your 1/2" angle shader with **White** in the heel and **Cadmium Yellow** in the point. Start under the smile and with short overlapping strokes work (half circular) toward the bottom picking up more **Cadmium Yellow** on the tip as you work. Your will have another layer of yellow on the edges and a lighter area in the middle.

Wet the surface of the apple with water using 1/2" angle shader and paint **Berry Red** line on the smile with your mini 2/0 fan brush. Wipe your brush and pull streaks down from the line using the corner of your mini fan brush following the shape of the apple. Paint **Berry Red** across the bottom, wipe brush and pull streaks to meet on sides but lift and leave middle open. Wipe brush often to get rid of the water that you are picking up from the surface. While the front is drying wet the area from the core to the upper edge and place **Berry Red** along upper and outer edge. Wipe brush and with corner pull gently toward the core, curving the edges and straight in the center.

Glaze across the top and down the left side with **Napa Red**. Re wet the core area and apply a little **Avocado** down in the core and pull out. Wet the surface again and pull streaks on the right side in toward the core with **Olive Green**.

Add strong highlights with **White** with the edge of your mini fan brush. Paint stems with **Burnt Umber** and highlight with a mix of **Burnt Umber** and **White** using your liner brush. Spatter with **Emperors Gold** mixed with a little water.

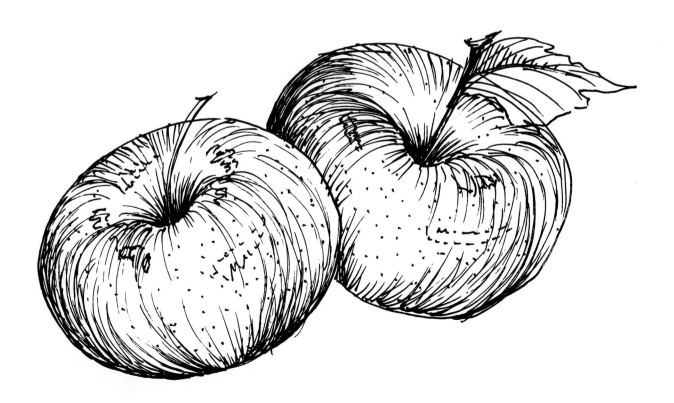

Watermelon

Undercoat watermelons with **White**. Paint basecoat of **Cadmium Orange**. Pull your 1/2" angle shader through **Cadmium Orange**, **Royal Fuchsia** and **White** picking up alot of all three colors. Let the colors mingle but do not mix. Pat the colors on the surface in different directions, leaving 1/2" next to the rind unpainted. Pick up more paint as needed and let colors vary.

Wipe your brush to get rid of some of the color and pick up **White** just on the tip of your brush. Create the light rind area by brushing across with short overlapping strokes. Paint the edge with **Evergreen** with a little **Faux Glazing Medium** using the edge of your 1/2" angle shader.

Pat in a few darker areas for seeds and shade the left side with **Faux Glazing Medium** and **Napa Red**. Paint seeds with **Paynes Grey** and highlight with **Titanium White**. Lighten a few places in front of the seeds to set them in with **Cadmium Orange**, **Royal Fuchsia** and **White** by scuffing the surface with very dry paint and using a small worn flat shader. Keep shapes irregular. Pick up **Faux Glazing Medium** in your whole 1/2" angle shader and just a tiny bit of **Olive Green** on the point, pull your brush on your palette, and paint a tint across the lower edge next to the rind.

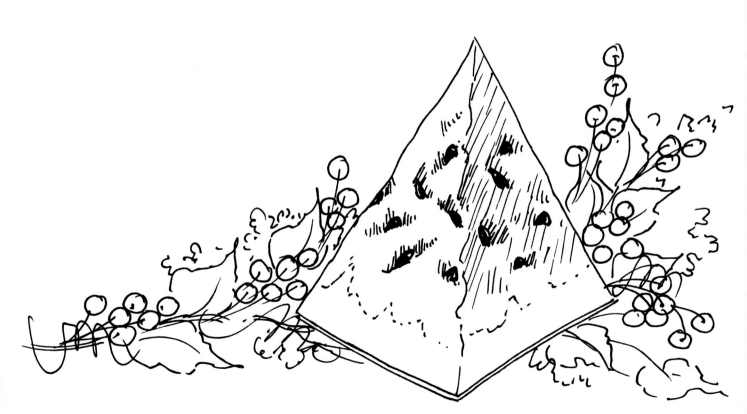

Watermelon

Titanium White

Royal Fuchsia

Cadmium Orange

Napa Red

Paynes Grey

Olive Green

Evergreen

Undercoat with
Titanium White.

Base with Cadmium Orange.

Dab with Royal Fuchsia, Cadmium Orange
and paint Titanium White at rind.

Paint seeds
with Paynes
Grey.

Glaze shadows
with Napa Red.

Highlight with
Cadmium
Orange, Royal
Fuchsia and
White.

Shade with
Napa Red.

Paint rind with
Evergreen, glaze
with Olive Green.

Pineapple

Titanium White

Cadmium Yellow

Antique Gold

Raw Sienna

Avocado

Evergreen

Base with Antique Gold and shade around edges with Avocado. Paint diagonal lines with Evergreen.

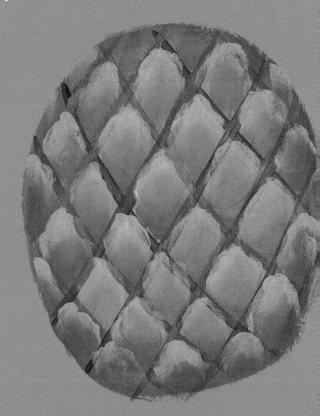

Highlight each section segment with Cadmium Yellow at top and Raw Sienna at bottom.

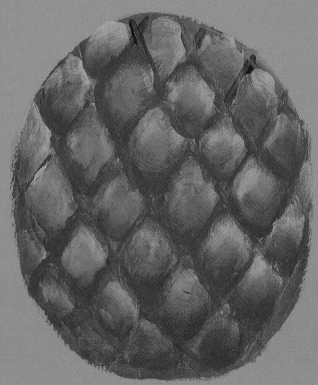

Shade each section with Avocado.

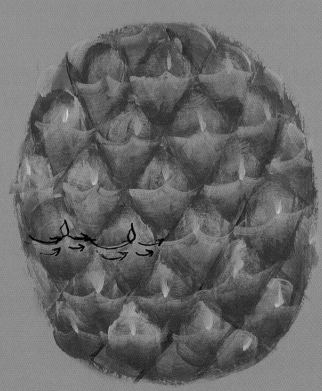

Pull across stroke with Antique Gold and Titanium White.

Pineapple

Base Pineapple shape with **Antique Gold** using your 1/2" angle shader. Dip the point of your dirty brush into **Avocado** and shade around the outside using short overlapping strokes. Let dry. Draw slightly curved diagonal lines both directions across the pineapple with your white chalk pencil. Paint over these lines with **Evergreen** using the chisel edge of your brush. Pick up **Faux Glazing Medium** in the heel of your brush and **Cadmium Yellow** on the tip and highlight the top of each section. Pick up **Raw Sienna** on the tip of your brush and **Faux Glazing Medium** in the heel and shade the bottom of each section. Pick up **Faux Glazing Medium** in the heel of your brush and **Avocado** in the point and paint all around each section messing up the edges over the **Evergreen** lines.

Pineapples have a membrane across each section. To create this effect pull across each section with **Faux Glazing Medium** in the heel of the brush and a mixture of **Faux Glazing Medium**, **Antique Gold** and a little **White** in the point of the brush. Start in the **Avocado** space between each section, pulling across, lifting in the center. Paint a little stroke in the center of each section with the same color using the tip of your #2 round brush.

Pineapple Tops

Pineapples have beautiful distinctive tops. I painted these using my 1/2" angle shader. Adjust size for larger tops.

*Paint Pineapple first then add tops. Practice these shapes by placing transparency film on top of this worksheet. Position brush like Tulip Leaves with the handle forward and the point down. Load your brush by dipping in **Faux Glazing Medium** and then pull through **Avocado, Evergreen** and **Olive Green**. Paint the longest stroke first, vary the length and spacing of the others. Pull side strokes with **Faux Glazing Medium**, **Avocado** and **Blue Mist** using the chisel edge of your brush. Note that the petals get shorter as you get down to the Pineapple. Pull wide strokes in the center with **Avocado** and **Blue Mist**. Let dry and add some turned tips with **Olive Green** using the tip of your 1/2 " angle shader or your #2 round. Make sure that some of these pull over the top of the Pineapple. Pick up **Faux Glazing Medium** in the heel and a little **Raw Sienna** on the tip of your brush and add little tips to each leaf. Shade with a little **Evergreen** to separate some of the petals near the bottom.*

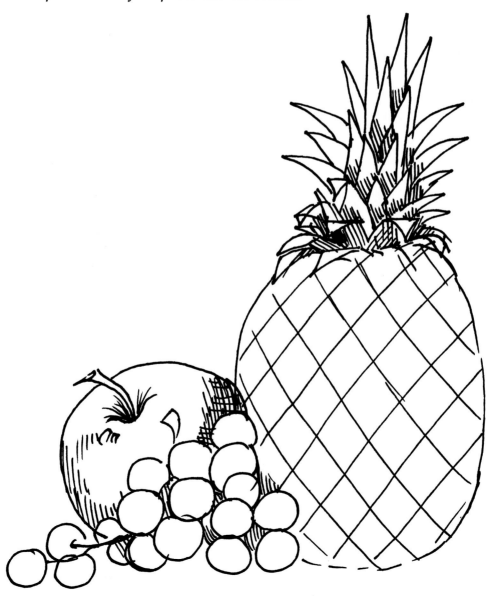

Pineapple Top

Avocado

Evergreen

Blue Mist

Olive Green

Raw Sienna

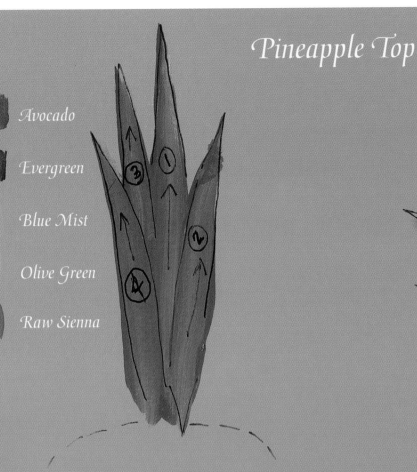

Pull strokes with 1/2" Angle Shader using Avocado, Evergreen and Olive Green.

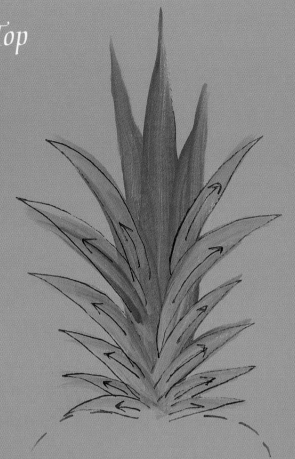

Pull side strokes using the edge of the brush with Avocado and Blue Mist.

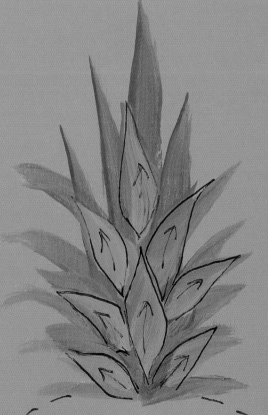

Pull strokes in front using Avocado and Blue Mist.

Add leaf turns with Olive Green. Paint tips with Raw Sienna.

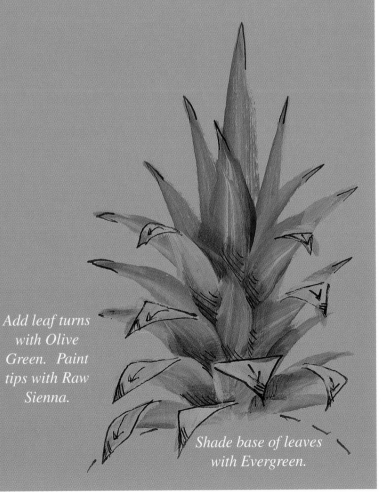

Shade base of leaves with Evergreen.

Lemons

Titanium White

Lemon Yellow

Cadmim Yellow

Antique Gold

Raw Sienna

Olive Green

Pinapple

Avocado

Dioxazine Purple

Paynes Grey

Basecoat with Titanium White.

Base with Cadmium Yellow. Tap highlight with Titanium White.

Tap Lemon Yellow.

Glaze with Antique Gold. Accent with Olive Green.

Deepen shade with Raw Sien

Tap Cadmium Yellow.

Kiwi

Shade edges with Avocado Tap rind with Raw Sienna

Base with Olive Green.

Highlight with double loaded brush using Olive Green and Pineapple.

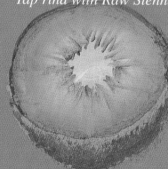

Add lines with Pineapple seeds with Paynes Grey.

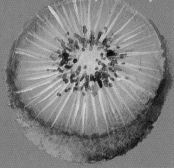

Tap rind with Raw Sienna.

Tap Olive Green, Avocado and Dioxazine Purple.

Lemons

Paint lemons with an undercoat of **White** using your 1/2" angle shader. When dry, paint again with **Cadmium Yellow**. Tap highlight with **White** using 1/2" foliage brush. Tap **Lemon Yellow** around and into the edge of the White. Use lots of paint to create texture. Tap **Cadmium Yellow** on lower edge. Allow to dry and glaze with **Antique Gold**, **Raw Sienna** and **Olive Green**. Re-highlight with **White** and **Lemon Yellow**.

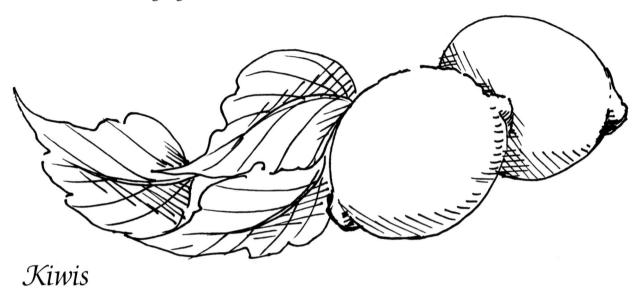

Kiwis

Base kiwis with **Olive Green** using 1/2" angle shader. Lighten the center of sliced fruit with a doubled loaded brush with **White** in the heel and **Olive Green** in the point and paint short overlapping strokes around keeping the point with the Olive Green to the outside and the heel with the White in the center. Glaze around the outside edge with **Faux Glazing Medium** in the heel and **Avocado** in the point of your brush. Add a few touches of **Avocado** near the center. Paint radiating lines with **White** with a touch of **Olive Green** using your liner brush. Add tiny seeds with **Paynes Grey** using the tip of your liner.

Tap rind with **Raw Sienna, Olive Green, Avocado,** and a little **Dioxazine Purple** using your 1/2" or 1/4" foliage brush. Touch lightly and mingle colors together.

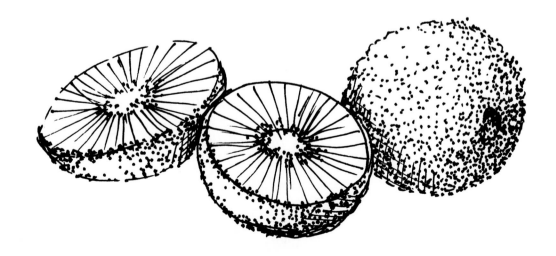

Cherries

*Paint cherries with **Cadmium Orange**. Paint **Royal Fuchsia** on the left side of each cherry. Highlight with **Jack O' Lantern** on the on the right side. Pick up **Faux Glazing Medium** in the heel of your 1/2" angle shader and **Napa Red** on the point and paint a "U" at the bottom and in between cherries. Paint a smaller "U" in the same manner near the top for stems. Add more **Royal Fuchsia** and **Jack O' Lantern** with your liner brush to strengthen color, adding some in front of dimple for stem. Strengthen dark with **Faux Glazing Medium** and **Dioxazine Purple** at the bottom and in between cherries. Paint little comma stroke with **White** using your #2 round brush.*

For quick cherries tap a 3/4" wooden dowel into colors and press to surface.

Green Grapes

*Paint green grapes with **Olive Green**. Shade down left side with **Blue Mist** or **Colonial Green**. Add **Evergreen** across the bottom. Highlight on the right with **Pineapple** & a touch of **Lemon Yellow**. Paint a little curved line of **White** for a shine. Accent with glaze of **Dioxazine Purple** in the yellow area on some grapes.*

Red Grapes

*I painted these grapes with **Cadmium Orange** using the 3/8" angle shader. Paint triangular shape on the top with **Berry Red**.*

*Be generous with your paint and just give each grape a swipe. Glaze with **Black Plum** in a "U" shape across the bottom. Highlight with **Jack O' Lantern** and **Faux Glazing Medium** on the right side. Pick up **Faux Glazing Medium** in the brush and a little **Blue Mist** and **Dioxazine Purple** on the tip and glaze on the lower left side. Paint bright **White** shine highlights. Strengthen colors as needed between grapes. Paint stems with **Burnt Umber** & **Raw Sienna**.*

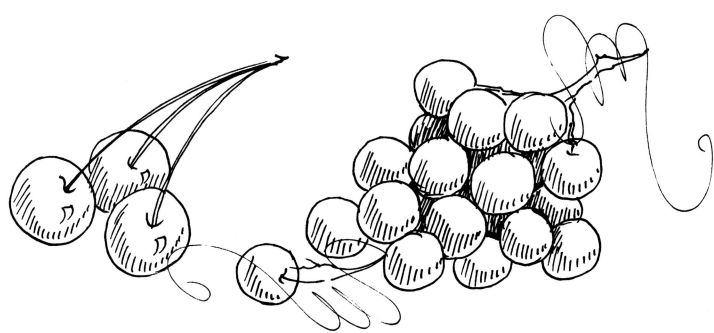

Cherries

Titanium White

Jack O' Lantern Orange

Cadmium Orange

Royal Fuchsia

Napa Red

Dioxazine Purple

Base with Cadmium Orange.

Add Royal Fuchsia.

Add Jack O' Lantern Orange.

Add highlights with Titanium White. Deepen with Dioxazine Purple.

"U" shape with Napa Red.

Strengthen using Royal Fuchsia and Jack O' Lantern Orange.

Green Grapes

Titanium White

Pineapple

Lemon Yellow

Olive Green

Blue Mist

Avocado

Doixazine Purple

Base with Olive Green.

Apply Blue Mist on left side and Pineapple and Lemon on right.

Strenthen colors.

Accent some with Dioxazine Purple. Highlight with White.

"U" shape with Evergreen.

Red Grapes

Titanium White

Cadmium Orange

Jack O' Lantern Orange

Berry Red

Black Plum

Blue Mist

Olive Green

Dioxazine Purple

Base with Cadmium Orange. Jack O' Lantern Orange on right side. Berry Red at top section. Black Plum "U" shape at bottom.

Stregthen colors.

Accent with Olive Green.

Glaze with Dioxazine Purple and Blue Mist. Highlight with Titanium White.

Strawberries

Titanium White

Cadmium Orange

Berry Red

Napa Red

Dioxazine Purple

Avocado

Evergreen

Blue Mist

Olive Green

Royal Fuchsia

Paynes Grey

Country Blue

Base with
Cadmium
Orange.

Highlight with
Cadmium Orange
and Titanium
White.

Paint Titanium
White diagonal
lines and round
corners.

Glaze all sides with
Cadmium Orange.

Glaze top, left
and bottom with
Berry Red.

Paint seeds with
Olive Green.
Shade with
Evergreen.

Glaze top and
bottom with Napa
Red.

Paint calyx
with Avocado,
Evergreen and
Olive Green.

Glaze left with
Royal Fuchsia.
Deepen shade with
Dioxazine Purple.

Unripe berry
leave light on
right and glaze
with Olive
Green.

Blackberries

Accent with
line of Napa
Red and
Titanium
White and
Country Blue.

Add highlight
of Titanium
White and
stem with
Avocado and
Olive Green.

Tap berries with cotton swab.
Row 1: Paynes Grey, Napa Red and Dioxazine Purple.
Row 2: Pick up more Napa Red.
Row 3: Pick up a touch of Titanium White or Blue mist on same cotton swab.

Strawberries

Undercoat berries with **White**. Paint basecoat of **Cadmium Orange** on all strawberries using 1/2" angle shader (size of brush is determined by the size of your berries). Highlight the center of each berry with double loaded brush with **Cadmium Orange** in the point of the brush and **White** in the heel. Keep the **Cadmium Orange** to the outside and the **White** to the center as you pat around. With **White** mixed with a little water, using your liner brush, paint diagonal lines across the berries forming diamond shapes to create the segments for the seeds. Paint little curved lines to round the corners of segments. Paint seeds with **Olive Green** & paint a little line down the left side of each seed with **Evergreen**. Allow to dry. Glaze the berries with **Faux Glazing Medium** in the heel of your brush & **Cadmium Orange** in the point all the way around the outside of each berry. Allow each layer of glaze and color to dry before adding another layer. Glaze **Berry Red** loaded in the same manner with **Faux Glazing Medium**, across the top, down the left side and across the bottom of each berry. Glaze **Napa Red** across the top and across the bottom of each berry.

Paint caps on each berry with small squishy leaves with **Avocado**, **Evergreen** and **Olive Green** using a small flat shader. Strengthen the color in a few places on the left side of the strawberry by glazing with **Dioxazine Purple**. Accent some berries on the light side with **Olive Green** to create some unripe berries. Add a touch of accent color on the dark size with **Royal Fuchsia**.

Blackberries or Raspberries

Touch the tip of your cotton swab into **Faux Glazing Medium** and then into the edge of **Paynes Grey**, turn swab and touch another side in **Napa Red** and **Dioxizine Purple**. Tap straight down to form a berry. Form a 1/2 circle. Pick up more **Napa Red** and tap second and third row. Now pick up a touch of **White** or **Blue Mist** on one side of the same swab to form the other side. Add a little accent line on the right side of each berry with **Napa Red** mixed with a little **White** using your liner brush. Accent on the left side of each berry with a little **Blue Mist**. Add a tiny **White** highlight. Paint stems with **Avocado** and **Olive Green**.

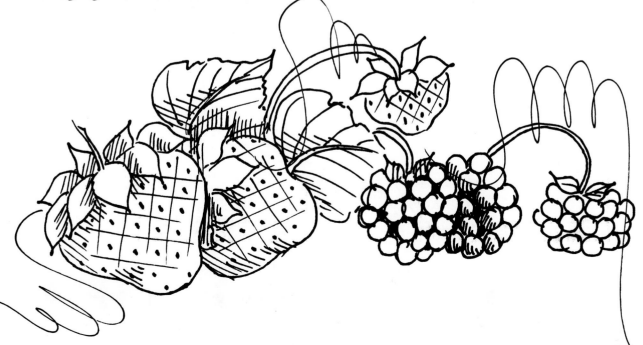

Heplful Hints continued

Transferring Patterns

Trace pattern onto tracing paper. Position the tracing paper pattern on surface and anchor in place using masking tape. Place graphite paper underneath the tracing paper pattern with dark side down. Transfer basic lines by retracing the pattern using a stylist or ballpoint pen. I like to use a red ballpoint pen so I can see which lines I have traced. Always check as you get started to see that the lines are transferring properly. Take your time; a clear, crisp pattern is worth the extra few minutes.

DecoArt Americana Acrylic paint is used on most of these projects. I love the thickness of this paint and the brilliant colors. I have used **DecoArt Faux Glazing Medium** with the paint on some of these projects to achieve transparent effects and to aid in blending

Wet Palette

Place a sheet of deli-wrap (dry wax paper) on top of several layers of wet paper towel or synthetic chamois in a tray or stay-wet box (9" x 12" or larger). Squeeze paint out on top of the damp deli-wrap surface. Paint will stay workable all day. Cover your paint and it will keep for days. The damp surface will keep the paint fresh but will not dilute your paint or allow it to skin over and get gunky. Purchase deli-wrap at party paper stores or warehouse clubs such as Costco or Sam's Club.

Definitions

<u>Basecoat</u> - To apply the first layer of color.

<u>Shading and Highlighting</u> - To apply color on top of the basecoat, both dark and light, to give dimension to your painting.

<u>Detailing</u> - To add fine lines, flower centers, stems, and other touches to give a finished look to your painting.

<u>Tapping</u> - To tap very lightly using the tip of the brush, bouncing around rather than moving in straight rows. Use this technique to create foliage or flowers.

<u>Double Load Brush</u> - Having two colors in your brush at the same time. First pick up the darker color on the heel of the brush then brush several strokes across the edge of the lighter value loading the point of the brush. Brush in the same places each time you pick up color. The desired effect is to have pure color on each edge or corner of the brush and a gradual blending of the two colors in the middle of the brush. I like to have more of my light value and less of the dark in my brush so that the light value will show more and the dark will not take over. I pick up the light value twice as often as the dark. On your deli-wrap palette pick up your color in the same place every time as you are creating a mix on your brush and on the surface of the palette at the same time. This mix will stay wet because of the damp surface so that you can continue to pick it up on your brush as you re-load with your light value.

<u>Transparent</u> - Painting with color that has been extended either with water or medium so that you can see through it.

<u>Antiquing or Glazing</u> - Used to tint areas of your painted piece to tone and soften. See Creating Special Effects.

<u>Spattering or Fly Specking</u> - To tone and soften your painted piece with tiny dots of color.

Scheewe Publications Inc. web site:
http://www.painting-books.com